IMAGES
of America

ROCHESTER'S CORN HILL
THE HISTORIC THIRD WARD

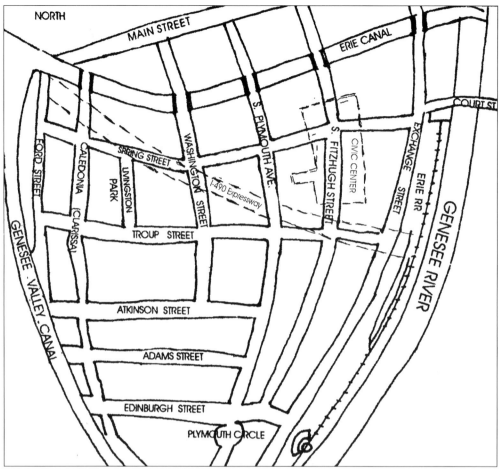

This basic map combines features of the original and present Third Ward. The area was surrounded by the Genesee River, the Genesee Valley Canal, and the Erie Canal. Entry to the ward was across narrow bridges, which gave the ward a kind of social isolation. Originally, the ward was three times this size. In 1844, the city expanded from five to nine wards. The map shows where Interstate 490 and the Inner Loop slashed through the heart of the neighborhood in the 1950s and 1960s and where the civic center was built on Fitzhugh Street.

IMAGES
of America

ROCHESTER'S CORN HILL
THE HISTORIC THIRD WARD

Michael Leavy

ARCADIA

First printed in 2003.

Published by Arcadia Publishing,
an imprint of Tempus Publishing Inc.
2A Cumberland Street
Charleston, SC 29401

Printed in Great Britain.

Library of Congress Catalog Card Number: 2003104865

For all general information, contact Arcadia Publishing:
Telephone 843-853-2070
Fax 843-853-0044
E-mail sales@arcadiapublishing.com

For customer service and orders:
Toll-free 1-888-313-2665

Visit us on the Internet at www.arcadiapublishing.com.

This book is dedicated to Elizabeth Holahan, a lifelong advocate of preservation. Her enthusiasm and love of Rochester's architecture was, and will continue to be, an inspiration for many.

CONTENTS

ACKNOWLEDGMENTS

I would like to thank the following for their unhesitating and often enthusiastic assistance: Dr. John Noble of the Municipal Photo Archives, Ira Srole and David Mohney of the Rochester City Hall Photo Lab, Cynthia Howk of the Landmark Society of Western New York, Julia Monastero of the Irondequoit Chapter of the Daughters of the American Revolution, and my twin brother, Glenn Leavy, who helped me snap all the pieces of the puzzle into place. The Web site of the Rochester Public Library was a tremendous resource. Among the printed references used are the Rochester Historical Society publications and *The Third Ward and Its Corn Hill Preservation District* (1984).

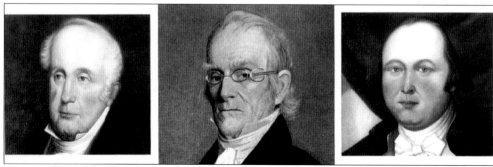

Rochester's founders, from left to right, are William Fitzhugh, Nathaniel Rochester, and Charles Carroll.

INTRODUCTION

Except for the Erie Canal, no other feature of Rochester captures our imaginations like the Old Third Ward. Of course the canal and Third Ward go hand in hand, one being the result of the other. The mention of Corn Hill—also known as the Ruffled-Shirt Ward because of the fashionable attire worn by its wealthy citizens—evokes images of Charles Dickens's era with its elegant brick mansions, ornate carriages, and genteel folk out for leisurely strolls. We imagine women with parasols and gentlemen greeting neighbors with a courteous bow and delicate tap of gold-tipped walking stick to the brim of a shiny beaver skin hat; of ruffled shirts, leather stockings, and Italian lace that has been carefully hand pressed by house servants. In winter, glistening sleighs were drawn up tree-lined streets, carrying passengers to homes of friends for, perhaps, a parlor game, a costume party, charades, or a music recital.

From the tall windows of soaring Greek Revival mansions, wealthy merchants could observe the activity on the canals and basins, where boats put in or set off with valuable merchandise. They could also see plumes of smoke from trains with cars full of coal and lumber and treasures from around the world that would give an exotic feel to the ward during the height of the Victorian era.

In terms of architecture and culture, Rochester was every bit as elegant as Charleston, Savannah, Natchez, or Boston. Here, penniless immigrants made fabulous fortunes overnight. They built their large homes with ballrooms and smaller music rooms for recitals but always with an eye toward hospitality. Their homes were repositories for European art and furniture with the occasional piece from the Orient. Moorish and Egyptian influences adorned columns and decorative features, as the typical Greek Revival style became passé.

The homes were meant to express the owner's wealth, but of greater importance were the schools, charities, and hospitals that were established in these homes. The glorious opulence of the ward was second, really, to the underlying civic-mindedness of the aristocratic citizens who regarded themselves, in a tribal sense, more as Third Warders than Rochesterians. Outsiders, aware the city's social hierarchy resided in the ward, especially during its peak during the Civil War, were envious and unhesitant in pointing out Wardians' penchant for being arrogant and snobbish. According to Charles Milford Robinson, true Third Warder status was achievable "only by birth, marriage, or immemorial usage, and that the chief and highest end of a Third Warder was to glorify The Ward and enjoy it forever, for while there were, politically, other wards in Rochester, socially there were none."

Further contemplation of the ward brings on disturbing contemporary images, as something terrible happened there—that being the near obliteration of this historic neighborhood. As early as 1895, Corn Hill was already being referred to as the Old Third Ward. Many families had left the mansions built generations ago by their forebears for East Avenue and the impressive Maplewood, Mount Hope, and Lake Avenue tracts. Some diehards held on, but slowly the ward grew increasingly dowdy and rumpled. During the Great Depression, some owners walked away from their once grand homes, unable to look back one last time. The pressure of the expanding city created an uncomfortable sense of restriction. One by one, large

homes were purchased by out-of-town landlords who were disinterested in maintaining the dignity of the ward. The energy force that was the culture of the ward slowly trickled out like blood from a wound. But there was change afoot in the form a fledgling sensibility that all this was wrong.

Contentious political battles and face-offs stiffened both sides, as those devoted to preserving the beautiful ward and those bent on postwar modernization clashed. The battle was quietly watched in other cities.

In the 1950s and 1960s, the federal urban renewal project, a major expressway, and the construction of a new civic center spelled doom for the ward. An armada of wrecking cranes bullied its way up the once dignified streets. The wrecking balls crashed through stained-glass windows and shattered hand-carved marble fireplaces. Grand curving staircases, where young belles were introduced to Third Ward society, snapped and crashed onto foyer floors.

Yet out of the smoldering dust of the shattered grandeur that was Corn Hill leapt the first sparks of a preservation movement that would give Rochester national prominence. The remaining portions of the ward still held some of its most historic structures, 700 of which were slated for demolition. The newly focused Landmark Society of Western New York developed a project to save them—and prevailed. The first conservation district in the city was formed. The proposals laid out by the society were so compelling that, suddenly, proponents of the absolute destruction of the ward now had a change of heart and became crusaders to save what was left.

Again, other American cities watched—and took note. The ward experienced a miraculous revival. Instead of wrecking cranes, flatbeds now lumbered up the streets bringing orphaned homes from other city neighborhoods that were threatened with destruction. Instead of bids for demolition of impressive homes, bids for carpenters and craftsmen were sent out. Preservation-minded folk from around America, Japan, and Europe marveled at the exacting restorations of landmarks such as the Hoyt-Potter House. Eager to save similar neighborhoods in their towns and cities, they later leaned forward with pen and paper to ask, "All right, now tell us how you did this." Rochester had established a national model for historic preservation.

Using some of the earliest images available, this work attempts to capture the glory, demise, and eventual resurrection of the Old Third Ward. Rare images dating from the 1850s show the evolution of the ward and the city.

The Old Third Ward is not just about significant architecture; it is about a culture of industrious pioneers who became great benefactors. The pioneers came shortly after the Revolutionary War to carve out a city in the wilderness. Some built their homes upon a hill where a farmer's corn crop was visible from the river—a place the villagers called Corn Hill. Hard work and sacrifice led them toward prosperity. We continue to prosper upon the foundations, traditions, and legacies they left us.

Undoubtedly they would be proud of those who struggled to preserve their ancestral homes and, in the doing, brought new life to Rochester and established a blueprint for other American cities.

One

FROM PIONEER
NEIGHBORHOOD TO
RUFFLED-SHIRT WARD

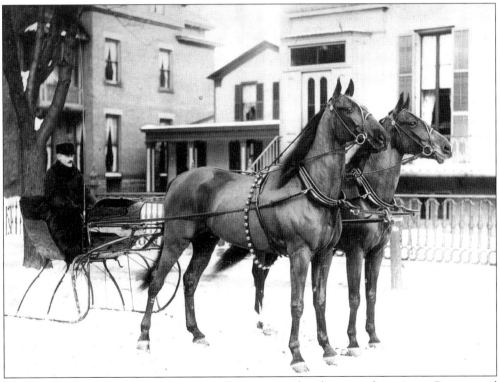

Charles Chapin, a local businessman and sportsman, has his two champions, Connor and Dariel, standing square on Fitzhugh Street for all to admire. The Third Ward was still the hub of fashion and elegance in 1893, the date of this photograph. Every square foot of the neighborhood was valuable; houses were, therefore, packed tightly on small lots. A wealthy merchant happily built his mansion between more modest houses just for the prestige of living in the ward. In spite of this, there was a pleasing unity to the streets. (Courtesy of the Rochester Public Library, Local History Division.)

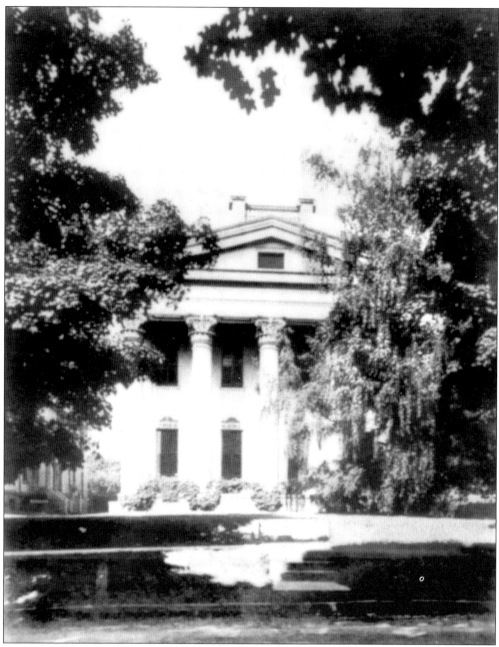

Most entrances to the ward were distinguished by a notable structure, but few were as grand as the Jonathan Child mansion. In a scene that could easily be mistaken for Savannah or Charleston, this monumental structure welcomes travelers to the ward in grand style across the South Washington Street Bridge. Jonathan Child, Rochester's first mayor, built this sumptuous Greek Revival near the Erie Canal in 1837 with profits from his canal trade. The Greek Revival style was the dominant force in American architecture from 1818 to the 1850s. Adaptable to both modest and grand structures, it was popular because of its simple dignity and the way it signified democracy. (Courtesy of the Rochester Public Library, Local History Division.)

Jonathan Child was one of 12 mayors who would live in the ward. His wife, Sophia, was the oldest daughter of Col. Nathaniel and Sophia Rochester. Having made a fortune from his Erie Canal enterprises, he made a serious legislative effort as mayor to improve the overcrowded waterway, calling for improvements to locks and construction of a new aqueduct over the Genesee River when the original began to crumble. A man governed by strict moral codes, he resigned as mayor after one year when he could not prevent the city council from issuing liquor licenses.

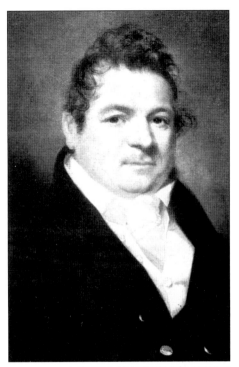

This simple structure was representative of Rochester's pioneer homes. Built on the east side of the river by Enos Stone, it was actually a step up from the rustic cabin that preceded it. As river, canal, and mill trade expanded, impoverished settlers were suddenly able to build more substantial homes. Their desire to be near the canal caused them to eye a hill where corn was grown—a place designated as Corn Hill. The elevation provided drainage for privies and wells. The mansions went up so fast that sometimes their studs were finished on only one side.

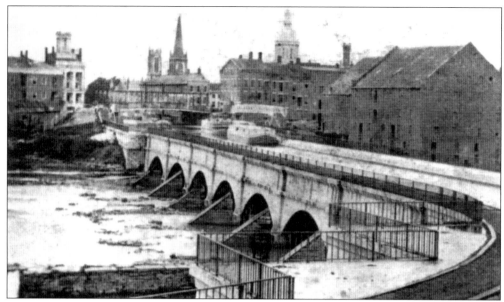

The Erie Canal brought incredible wealth to the fledgling city, resulting in America's first real boom town. This early stereo view of the aqueduct looks west and shows parts of the Exchange Street Bridge. Exchange was a colorful street that started at Buffalo Street (West Main) and traveled south through the ward. The tower of the courthouse is to the right of center. The slender spire to the left is the Old Brick Church, on South Fitzhugh Street, with St. Luke's steeple across the street. Farther left is the tower of the Rochester House, a famous hostelry on Exchange Street with a wing on Spring Street. The hostelry was destroyed by fire in the early 1850s and was rebuilt shortly thereafter.

Col. Nathaniel Rochester moved to the village in 1818 and built this house on the northeast corner of Spring and South Washington Streets in 1824. Settlements on both sides of the river were well on their way before William Fitzhugh, Charles Carroll, and Rochester laid eyes on the 100-acre tract they had purchased jointly in 1803 from the Pulteney estate. Fitzhugh and Carroll preferred to lord over their Genesee Valley lands, where they built their homes, the Hermitage and Hampton, leaving to Colonel Rochester the administration of the village. Rochester proved to be a sensible leader, smoothing over differences between rivals in the area. Before moving to the village, he freed the 10 slaves he brought from Maryland and always condemned slavery afterward.

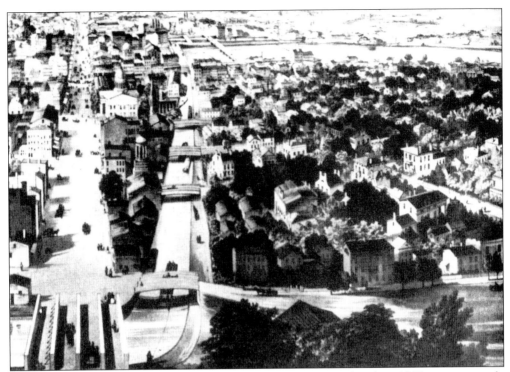

This detail from a lithograph of Rochester from the west, rendered in 1853, is surprisingly accurate. In this bird's-eye view drawn by Charles Magnus, the Erie Canal is visible to the left, with the bridges leading into the Third Ward almost to the river. The ward is to the left, with landmarks such as the Montgomery House, the Child House, Livingston Park, and the Reynolds House visible to the discerning eye.

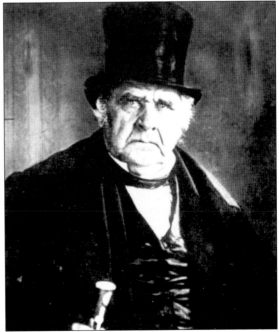

In spite of his stern aspect, Elisha Johnson could liven things up. He began blasting for his Johnson-Seymour millrace on the Fourth of July 1817 so the explosions would stir the population into a celebratory mood. The millrace remains to this day, the overflow spilling through outlets under the Rundel Library. Among his engineering feats were construction of a new Main Street Bridge in 1824 and a three-mile horse-drawn railroad that ran north to the landing at Carthage in 1832. In 1838, he became Rochester's fifth mayor, and he later became chief engineer of the Genesee Valley Canal. (Courtesy of the Rochester Public Library.)

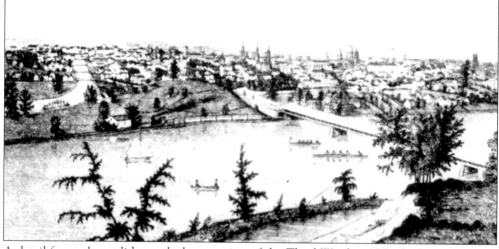

A detail from a larger lithograph shows a view of the Third Ward in 1854, looking northwest from Mount Hope. In the foreground, fishermen try their luck in the feeder canal that ran along the east side of the river and connected with the Erie Canal just south of the aqueduct. Boaters ply the Genesee River around the Clarissa Street Bridge. The rise of land that designated the name Corn Hill is evident. The Genesee Valley Canal makes a sharp turn in the upper left.

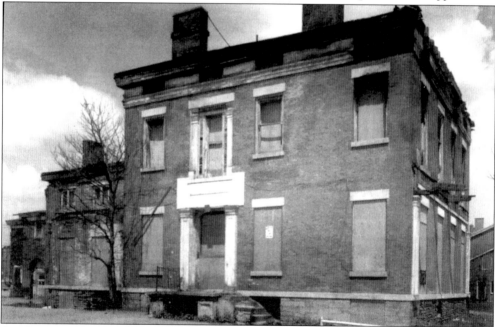

A contentious 20-year struggle resulted in saving the Hoyt-Potter House. In this Richard Margolis photograph taken in late 1980s, the house is a sad, decaying ruin, having been subjected to a fire, leaks, and vandalism. When the house next door was to be demolished, Corn Hill citizens stood between it and this house lest the operator of the wrecking ball, working under implied orders, give the ball extra swing back into this house, delivering a spiteful deathblow.

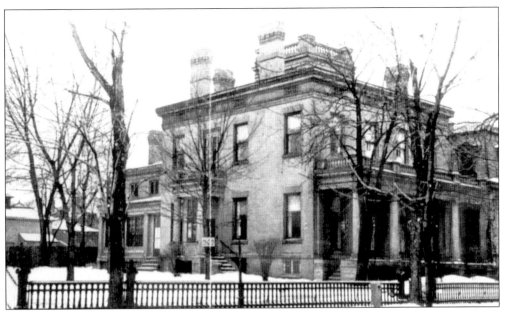

The Hoyts built this superb Greek Revival on South Fitzhugh Street *c.* 1840. Hoyt ran a book and stationery store, and Mary Hoyt helped found the Rochester Orphan Asylum. Henry and Harriet Potter purchased the house in 1850. Henry Potter was a stockholder, director, and organizer in an early communications business that evolved into Western Union. (Courtesy of the Landmark Society of Western New York.)

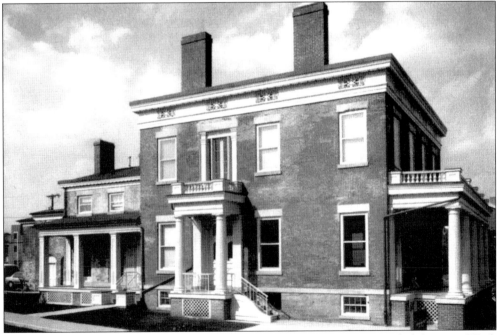

Threatened with "demolition by neglect," the house underwent a major rehabilitation. Work was well under way when Richard Margolis took this comparative photograph in the late 1990s. At that time, the double parlors were being rehabilitated to reflect the grandeur of the 1850s, when the Potters owned it. (Courtesy of the Landmark Society of Western New York.)

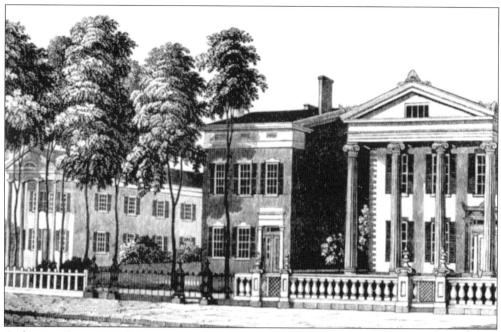

A drawing from O'Reilly's *Sketches of Rochester* depicts a section of the west side of South Fitzhugh Street with all the charm of the 1830s. Although the lots were usually small, fences unified much of the ward, so there was an overall feeling of being in a park. Most residents kept their grounds neat and lush. The structure to the left is the Rochester Female Seminary. A typical brick residence of the ward is in the center. Rufus Meech built the impressive home on the right, which was acquired by W. Mudgett in 1875.

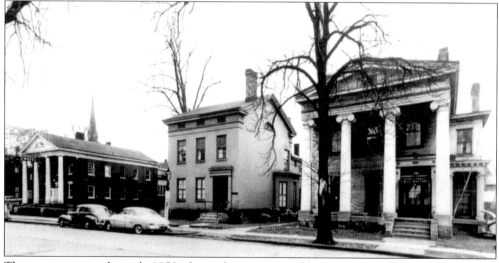

The same scene in the early 1950s shows the area stressed by an expanded city. The fences are gone and the buildings are now neglected but useful relics adapted to modern use. Landlords were disinterested in any neighborhood continuity. Note how sturdy the structures remain—a tribute to the Wardians who built them. The seminary is now the Fitzhugh Hotel, and the two other buildings are apartments. This photograph was taken just before the block was razed for the civic center. (Courtesy of the Landmark Society of Western New York.)

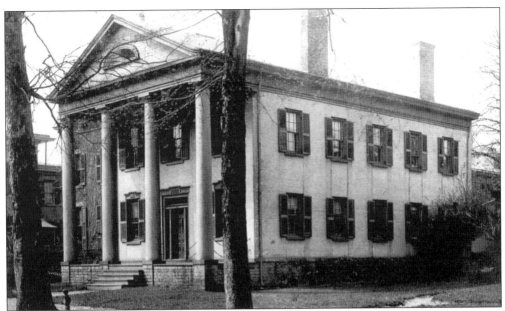

The c. 1835 Rochester Female Seminary was closing its doors as Mrs. Nichol's School in 1903, the date of this photograph. It was variously known as the Rochester Female Academy and Miss Doolittle's School. Here, belles of the Third Ward were instructed in the classics, piano, and proper social etiquette—a restrictive blend of Victorian cordiality and Third Ward puritanism. Having Susan B. Anthony nearby did much, however, to begin loosening the strict womanly reserve expected by Third Ward rules of conduct. (Courtesy of the Rochester Public Library.)

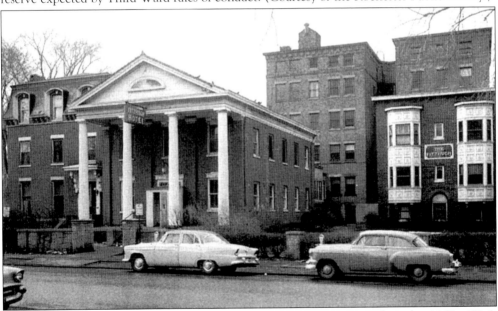

The school retains little of its original charm as the Fitzhugh Hotel in the 1950s. With Rochester's Main Street mere blocks to the north, the quite dignity of this part of the ward had long since been bludgeoned away, as newspapers and debris now blow down the sidewalks. Urban renewal and other civic projects have slated this block for demolition. (Courtesy of the Rochester City Hall Photo Lab.)

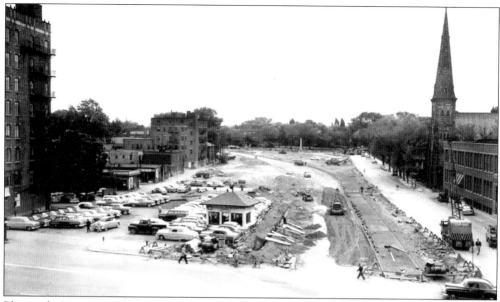

Plymouth Avenue residences have been bulldozed to make way for the civic center complex. Broad Street, the former site of the Erie Canal, is in the foreground of this 1950s photograph. Plymouth Avenue is to the left, and the c. 1872 First Presbyterian Church is on the corner of Spring Street. Designed by A.J. Warner, the church reached a height of 160 feet. In 1976, the building became home to the Central Church of Christ. (Courtesy the Rochester City Hall Photo Lab.)

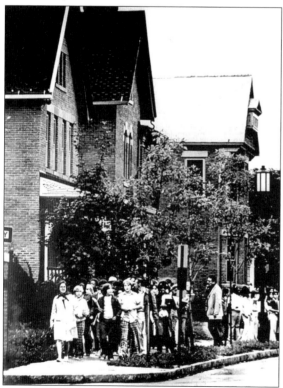

The ward deteriorated steadily during the 1950s. In the 1960s, the coming Apollo moon missions created prospects of ultramodern cities, which caused city planners to contemplate using the federal urban renewal program to demolish the entire historic neighborhood. The Landmark Society began to focus on broader preservation of the area instead of preserving individual structures. In the end, the preservationists won out by convincing city planners that rehabilitation was viable and constructive to urban living. Here, students walk up Atkinson Street during a school tour of the ward in 1974. (Courtesy of the Landmark Society of Western New York.)

Two

THE CIVIL WAR ERA

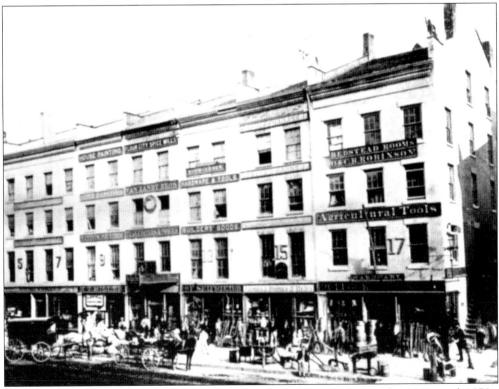

Many believe the ward reached its peak of social prominence during the 1860s and 1870s. During the Civil War, the "old families" sponsored bazaars and opened their homes for fund-raising balls, socials, lectures, and waltzes. This block on Buffalo Street (Main Street West) shows a day of busy commerce. Except for the portrait of Millicent Backus Alling (page 39), the photographs used in this chapter date from the 1850s, 1860s, and early 1870s and effectively re-create the city and Third Ward of the Civil War era. Passages from a daily journal kept by a Rochester boy in 1864 are used to provide insights into daily life during the war. (Courtesy of the Rochester Public Library.)

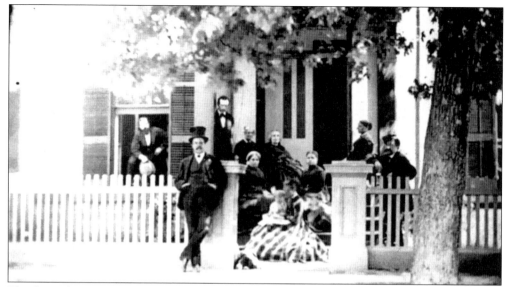

Third Warders, or Wardians, enjoy the shade of a front yard, probably on Spring Street. Attired in ruffled shirts, hoop skirts, and calico, they appear close-knit and comfortable. A young Rochester boy left many details about those days, though he did not leave us his name. Entries suggest he came from a Third Ward family such of this, and that his father ran a store. "The hired girl left today. She got mad cause I mixed some plaster of paris in her bread flour and she made some bread and pa said when he tried to eat it, 'What in blazes is this?' Folks don't never appreciate a boy's jokes." (Courtesy of the Landmark Society of Western New York.)

Col. Nathaniel Rochester wrote in 1825: "There can be no doubt but that Rochester will be one of the great manufacturing places in the United States. It embraces more local advantages than any place I have ever seen." The falls that brought prosperity during peace now powered factories for the industrialized North's war effort. Meanwhile, the young Rochester boy seemed more concerned with pranks and schemes to get out of school than with the war. His entry for May 8 was an exception: "Washed and went to church. The *Express* got out an extra as there was news that Grant had licked Lee and drove him back to the defenses of Richmond. I sincerely hope we have a victory. I sold some of the extras and pa licked me for selling them on Sunday."

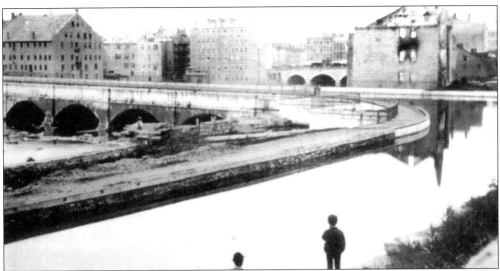

The canal held its own, competitively, with the railroads during the war. For the young writer, the canal and river were for swimming, boating, and fishing in the summer and ice-skating in the winter. Watching "canallers" fight over who passed under a bridge first was a regular pastime as well. The canal and river were a nightmare waiting to happen for parents. As early as 1834, parents were warned to keep their children away. After a five-year-old drowned in a millrace near the aqueduct, a witness told the local newspaper, "That is the fifth child I have seen taken from that millrace in three years."

Further journal entries mention visiting friends whose brothers are home from the war, convalescing from illnesses or letting wounds heal. The young writer was apparently old enough to fight because several times he talks about enlisting. On February 8, he wrote, "Went to school. Went to Rumsey's Minstrels. One of the Ellsworth zouaves was on his way to New York and to Paris to compete with the best drilled men there. I never saw a man so well drilled in my life. I am going to drill." Pictured is Maj. James S. Graham of the Rochester Light Guards. (Courtesy of the Rochester Historical Society.)

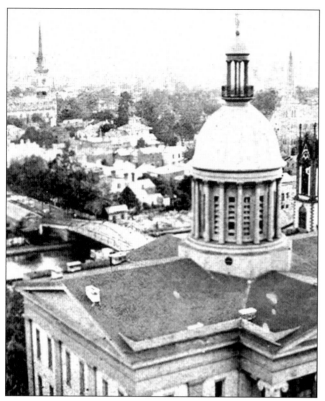

During the war, the courthouse was the scene of rallies, addresses, announcements, and celebrations. In this stereo view, the Fitzhugh Street Bridge over the canal is visible just beyond the courthouse roof. In the distance is the grand matron of the ward, the Plymouth Congregational (later Spiritualist) Church. An October 14 journal entry reads, "In the evening the republicans had a procession of four transparencies [carriages] and about 100 men. They were firing a cannon on Fitzhugh Street Bridge and the democrats took it away from them and they had a real free fight. It was a lot of fun. We sniped [stole] a lot of powder while they was fighting. When folks get to fighting a boy most always has a chance to get something." (MLL Collection.)

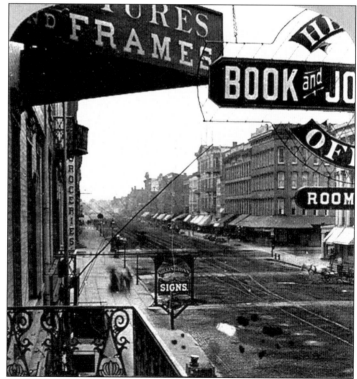

West Main Street looks well trampled in this stereo view. There are streetcar tracks in the center of the road. Originally, omnibuses carried passengers in the four directions leading from the center of the Four Corners. Streetcar railroads began operation c. 1863 amidst opposition that they were "an obstruction to the streets, the imminent danger to life and limb, and the annihilation of comfort and quiet by the clatter and racket of the swiftly moving cars." (MLL Collection.)

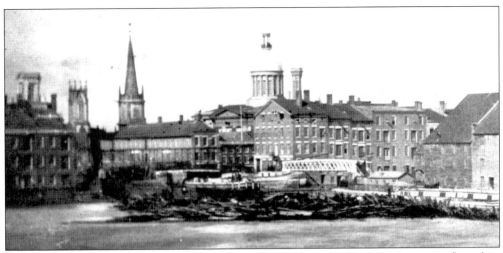

As if the war were not stressful enough, on March 18, 1865, the Genesee River overflowed its banks in the city's worst flood. A logjam of trees, flotsam, fencing from farms upriver, and the bloated bodies of horses and cattle pressed dangerously against the aqueduct. The yellowish torrent flooded the city from St. Paul to the Four Corners. State, Mill, and Front Streets were hit hard. This view is looking west where canal bridges crossed into the ward. The courthouse tower can be seen in the center. To the right of the courthouse is the spire of Central Church, on North Plymouth Avenue, and to the left is the spire of the First Presbyterian Church, with the bell tower of St. Luke's Church across South Fitzhugh Street.

The National Hotel stood on the northeast corner of West Main and North Fitzhugh Streets. The Powers Hotel later occupied this site. The National was an architectural marvel for its time because of its curved and columned galleries. Visiting dignitaries often stayed here and gave speeches on everything from Free Masonry, abolition, and temperance to impending doomsday. During the war, the hotel was also the site of Ladies Aid Society fund-raisers for the families of soldiers. (MLL Collection.)

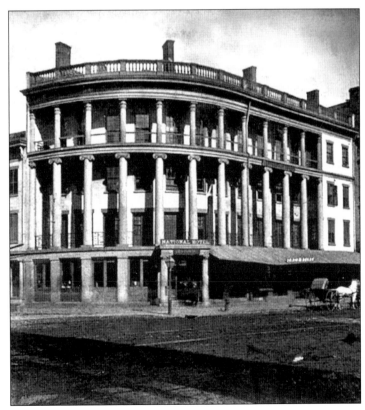

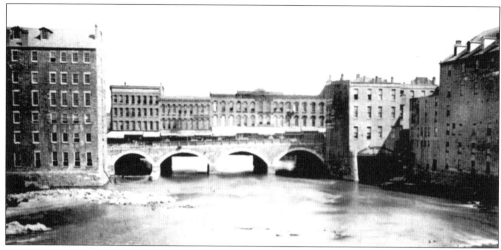

An 1860s view of the river looking north shows the Main Street Bridge, with buildings only on its north side. Large groups used the area from the bridge to the courthouse for rallies. The young writer's journal entry noted that "We got out of school at 10 o'clock to see the forming of a republican procession. I should think it was a mile long if not more. In the evening they had another procession. A mortar burst and hurt several [onlookers]. There was lots of other fireworks and interesting things. I marched in the procession, as did all the other boys. Pa was mad cause he said I was a democrat and what did I want to march with them cussed republicans for but when I get a chance to march in a procession I am not going to let politics interfere." (Courtesy of the Rochester Public Library.)

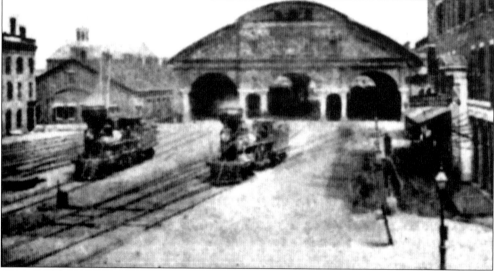

Two wood-burning locomotives roll out of the New York Central and Hudson River Railroad's Mill Street terminal c. 1858. The railroads prospered during the war, transporting supplies and troops. The major lines were chastised for charging high fees to transport dead soldiers home from the battlefield. Rochester had a three-mile-long horse-drawn railroad in 1832. In 1837, the first steam-powered locomotive chugged out of Rochester on the Tonawanda Railroad, founded by Jonathan Child, Frederick Whittlesey, and Elisha Johnson. That depot was in the middle of Buffalo (West Main) Street. Trains to Batavia then went through an impressive 178-foot-long covered bridge at Clarissa Street.

Workers pose outside Gleason's, a machine shop in Brown's Race in 1865. Later, the shop manufactured gear-cutting machinery that was among the finest in the world. The roof of the massive New York Central and Hudson River Railroad train shed is visible behind the men standing on the elevated cross bridge. The young writer mentions a similar factory: "Went to school and got excused and went down to Kidds foundry and saw them mold a big fly wheel."

Monroe Savings Bank built this office on State Street in the 1860s. Note the sleighs. The young writer's journal has numerous entries about sleighing in the ward. "I had the horse and cutter this afternoon. Pa don't know it. Went out on the avenue. There was thousands out. For a wonder I couldn't think of an excuse to stay out of school. Had a race. I tipped over but guess I didn't break nothing. A man caught the horse." The journal also mentions skating on the river that week. "Went skating. Played hookey from school. Thousands on the river. It cost me five cents to go on the ice but most always I can find a way to sneak on. . . . Stayed till 8 o'clock. Cora is my girl now."

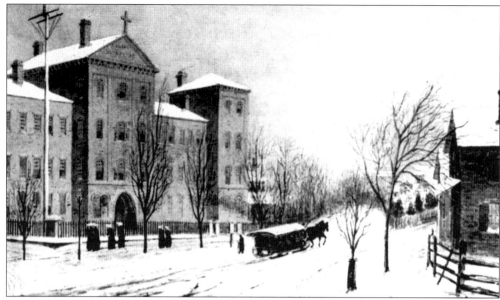

This is a detail from a larger painting showing St. Mary's Hospital at Bull's Head Corners *c.* 1865. The hospital was beyond the west boundary of the ward. When snow was high, wheeled streetcars were replaced with horse-drawn versions like the one seen here. Wounded and ill soldiers arrived in the city sometimes by stage but usually by railroad. (Courtesy of the Rochester Historical Society.)

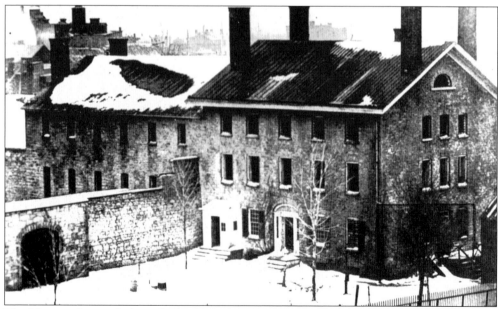

The Monroe County Jail was built in 1832 on a small island south of the Court Street Bridge between the Carroll-Fitzhugh millrace and the west bank of the river. It was nicknamed the "Blue Eagle," from a poem scribbled on a cell wall by a circus clown named Dan Rice. The courtyard beyond the wall was used for executions by hanging.

The City Hospital opened on West Main Street in 1864 under the care of the Rochester Female Charitable Society, organized in the Third Ward. From 1864 to 1865, the hospital received 448 soldiers, many from Gen. Ulysses S. Grant's bloody Virginia campaign to capture Richmond. The battlefield produced a second generation of medical men who went on to move medicine and surgery out of its archaic state. In 1911, the hospital's name was changed to Rochester General. (MLL Collection.)

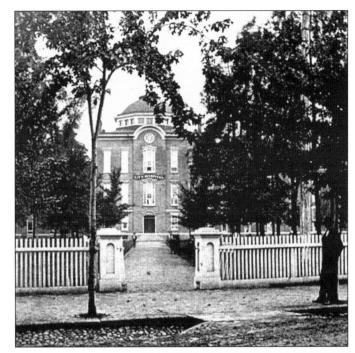

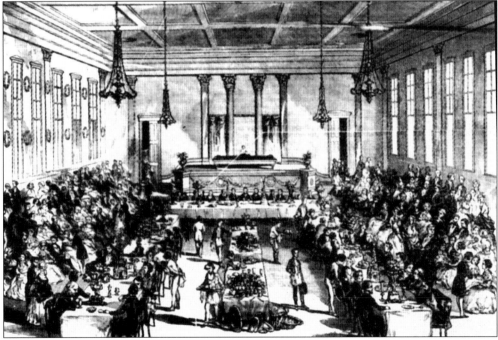

In 1849, William A. Reynolds built the Athenaeum building, which included Corinthian Hall, pictured here. In 1858, William H. Seward delivered his famous "Irrepressible Conflict" speech to a wary crowd. Shortly after the election of Abraham Lincoln, Susan B. Anthony and Frederick Douglass spoke at the hall and were met with protests. In spite of antislavery sentiments, no one was anxious for war. The hall was used for fund-raising bazaars and expositions during the conflict. Ralph Waldo Emerson was among the celebrities to speak here.

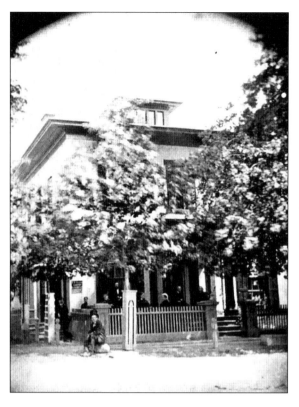

The Rochester boy and his friends were pests during those awful days. The writer is anxious for a new gun after having raised havoc with his old one. "It cost me 50 cents to pay for the rooster I killed. I didn't mean to kill him but he run right in front of my pistol." After shooting at a runaway horse by the aqueduct, the owner confronts his father. "The man that owned the runaway told pa that if he didn't take that gun away from that dam boy somebody would get killed." Another time he and his friend Mort hop a train to Charlotte. Afterward, "The conductor wouldn't let us on the train cause when we went down Mort and me was fooling around and the gun went off and blew a hole in the roof of the car." He also likes to race the family horse up the streets of the ward, "Had a race up Troup Street to Sophia to Atkinson Street to High Street. I beat." (Courtesy of the Landmark Society of Western New York.)

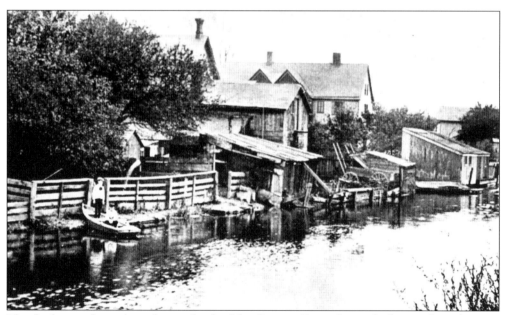

This feeder canal ran along the east bank of the Genesee River. It supplied water from the river to the Erie Canal to maintain its depth and increase the current. It was used for transporting goods as well. The young writer mentions that he "Got the horse and my dog and went riding up the Feeder road."

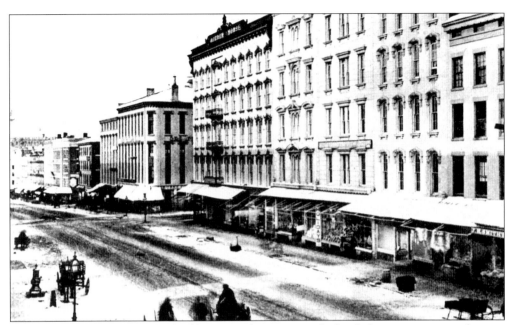

In this quiet wintry scene, the building near the center with the dark ornamentation along its top is the Osburn House, on the corner of Main and St. Paul Streets. Built by Nehemiah Osburn, the five-story hotel had 150 guest rooms on the upper floors, a reception area on the second floor, and stores on the street level. The young writer mentions the hotel: "Last night I slept down to the Osburn house with Adams and we got an early start for duck hunting." At the lower left is a small potbelly stove, which has been rolled onto the street for ash pickup.

A closer look at the Osburn House shows a busy commercial block. At a quick glance, the gentleman on the small balcony might cause someone to think of Abe Lincoln, but this image is c. 1857. Well-dressed attendants and a waiting carriage suggest this was a promotional picture taken when the establishment opened. (Courtesy of the Rochester City Hall Photo Lab.)

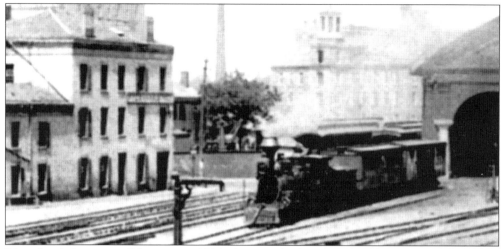

This detail from a well-known *c.* 1864 photograph shows the Mill Street station, where Abraham Lincoln stopped during his inaugural train ride and again when his funeral train came through. A small 4-4-0 engine is pulling boxcars out of the terminal. Railroads were irresistible to boys, including the young writer, who tells of a dangerous stunt: "Had some fun in the evening with Dewey, Munger and Ethridge. We tied a rope on a little building along the railroad tracks and then run it across the tracks and tied it to a tree. The train come along and hit the rope and the building went everyway. It was lots of fun. A Boy can't have no fun unless he busts something and folks aught to be glad to have things busted by boys cause then they know they've got boys."

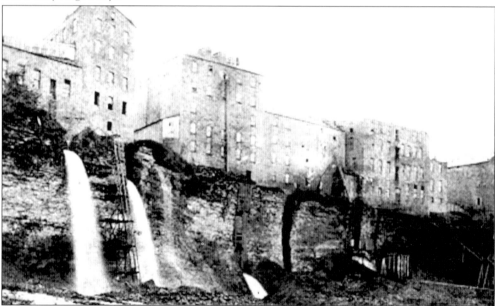

The mills and factories along Brown's Race were perfect for exploration but were dangerous as well. Along the narrow cobble streets were large derricks and industrial equipment. Rats had the run of the place because of the abundance of grain stored here. These structures were atop deep, damp mill cellars. Water was diverted from the river beside the falls by a millrace. Sluiceways along the race were opened to allow water through to turn the massive mill wheels. The river wall has been hacked so the runoffs can spill back into the river.

A c. 1864 stereo view shows a daredevil's tightrope stretched from the east bank across the falls to the mills on Brown's Race. The young writer is excited: "September 18. Fred and me went over to the railroad bridge to see that rope that is across the river below the falls which Donaldson is going to walk during the state fare [fair] next week with a man." On September 21, he wrote, "There wasn't any school today on account of the fare. Four trains arrived here this morning of 50 cars each all perfectly crammed and jammed with folks. There was about 7,500 at the fare." (MLL Collection.)

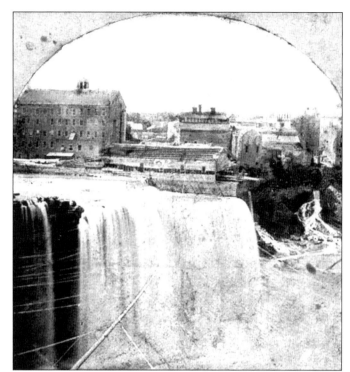

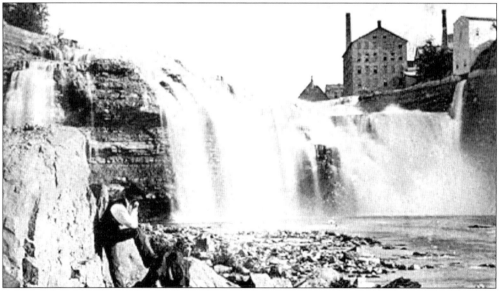

The Lower Falls, farther north, were busy with mills. It was a realm that provided endless delights for youngsters, including the keeper of the journal: "In the afternoon went down to Fergusons on the street cars. Met Mort down there so we went swimming down by the lower falls. I lost one of my boots. The way I lost my boot was some eastsiders was down to the falls and one of them swum across the river and filled my boot with stones and threw it in the river. I'm going to dive for it." A rivalry had developed between citizens on the east and west sides of the river. They usually worked it out through baseball games and other competitions. More severe injustices were usually settled with gangland fistfights.

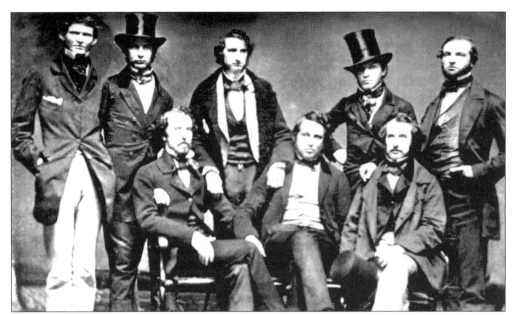

Eight prominent Rochesterians pose for a photograph in the 1860s. They influenced the educational, political, financial, and social life on the city. From left to right are the following: (front row) John H. Rochester, a banker and grandson of Nathaniel Rochester; Chester P. Dewey of the *Daily American* and son of Chester Dewey; Edward M. Smith, mayor in 1869; (back row) A. Carter Wilder, mayor in 1872; Dr. Azel Backus, physician and grandson of Col. William Fitzhugh; Gilman Perkins, financier; Samuel Wilder, financier; and Hobart Atkinson, dean of Rochester bankers. (Courtesy of the Rochester Historical Society.)

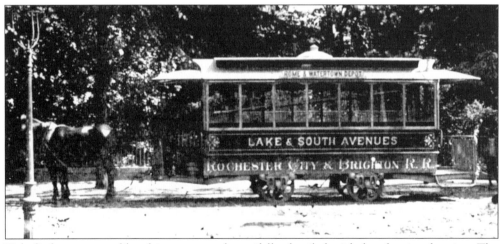

Tidy little streetcars like this one were beautifully detailed with hand-painted script. The diagonal bar visible through the windows is where the customer would set his nickel fare. It would roll down to a box behind the conductor. The young writer refers to taking the "cars" to the lake. "Went to school in the morning but in the afternoon Fisher and me went down to the bay. We fished a little and then went up to the Newport house as they was a picnic there. Went down to Sea Breeze and et the lunch we got from the picnic. We got a eel down to the bay and put it in one of the picnic baskets. You ought to heard the women scream."

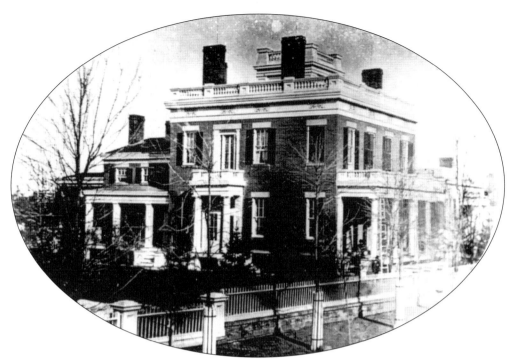

The house built on South Fitzhugh Street by the Hoyts and then sold to the Potter family in 1850 is romantic and orderly in this winter view. Homes like this one were built with an eye toward entertaining. During and after the war, costume parties, socials, amateur theatricals, and waltzes were held to raise money for charities. Later, such activities occurred in clubs. The small trees along the road are loosely bound with wood slats. This was done to keep horses from nibbling the bark while tied up at hitching posts. (Courtesy of the Landmark Society of Western New York.)

The Opera House on South Avenue was built in the 1850s and was frequented by those eager not only for culture but also for humorous diversion. Stage plays, comedies, operas, and concerts were performed on an elaborate stage. Citizens were eager to escape the dreadful reality of the war, even if only for an hour or two. (Courtesy of the Rochester Public Library.)

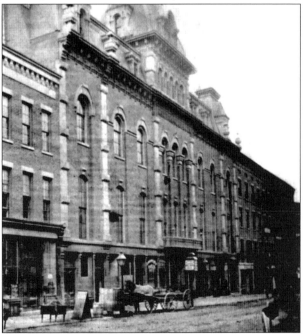

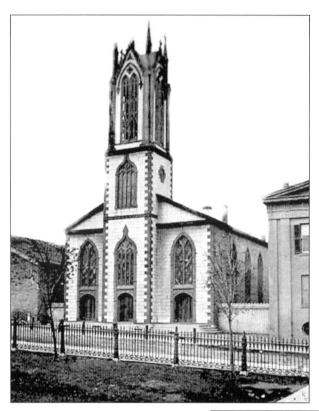

Nathaniel Rochester provided the lot on South Fitzhugh Street for St. Luke's Church, built within the original 100-acre tract in 1825. To the right is the corner of No. 1 School, where Philip Roeser, cousin to Napoleon Bonaparte, taught for some time. Roeser also had a school in his Sophia Street home, where he taught until 1840. Called the French and Mathematical School for Young Ladies and Gentlemen, its students included Silas O. Smith, Hiram Sibley, Patrick Barry, and George Ellwanger. Numerous times the young writer refers to St. Luke's, which his family attended. "Washed and went to church . . . the reason we had to change our seats was that old Smith who sits ahead of us got mad cause I dropped a spyder down his wife's back and she screamed right out in church."

In his June 5 entry, the writer indicates that families often attended other churches in addition to their own. "Went to church in the evening with Fay. We went to Brick, Central, First, Baptist and St. Paul's churches. Shaw had a sermon on the Mt. Hope outrages. Guess I got enough religion today." The Mount Hope outrages involved youngsters writing on headstones in Mount Hope Cemetery, something the writer knew more than a little about. In this view a streetcar has stopped in front of the Asbury Methodist Church, on the southeast corner of Main Street and South Clinton.

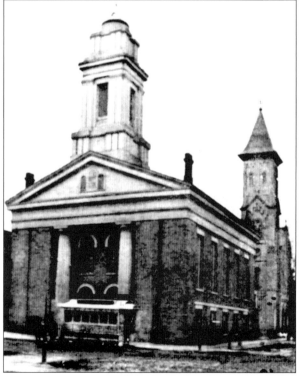

This interesting 1860s stereo view, taken from West Main Street, shows Central Presbyterian Church, on North Plymouth Avenue. The unique tower is visible in many cityscapes of that era. Almost a century after this image was taken, the church became home to the Hochstein Music School. (MLL Collection.)

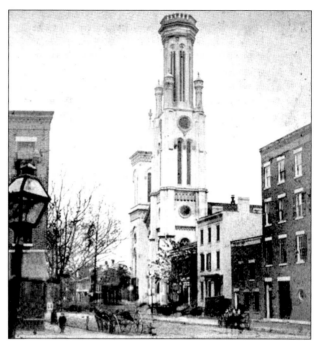

"Washed and went to church twice. Fred and me when down to Frankfort and got back in time to see the 54th [regiment] have a dress parade in front of city hall. About 5 o'clock they went to the Valley depot to escort the Union Grays who come from Elmira from guard duty." The parade mentioned by the writer would have been near here—the First Presbyterian Church was located in Court House Square. The "Valley depot" was the Genesee Valley Railroad, which preceded the Erie line along Exchange Street. This photograph was taken after the church burned in 1869. Its successor was built at South Plymouth Avenue and Spring Street.

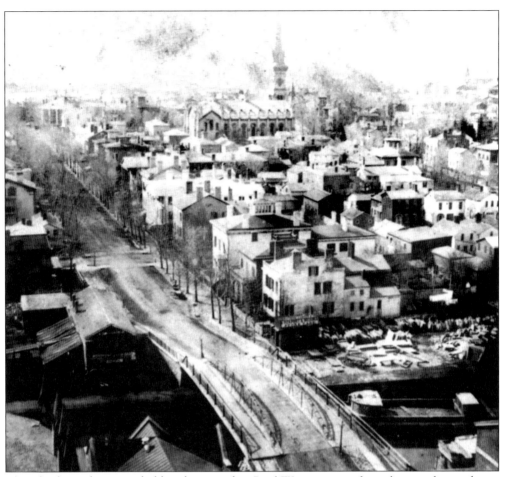

The Third Ward appears darkly solemn in this Civil War–era view from the courthouse dome. The young writer says he was disappointed that Pres. Abraham Lincoln was reelected. He then tells us that, during a baseball game, "We got in a fight with a big Irishman and all had a punch at him. He hit me in the neck with a stone." In spite of this, the boy's life is relatively carefree when compared with the lives of his counterparts in Southern cities. Civil wars are among the worst because battles are not fought only on battlefields. Sometimes, the fighting moves into populated areas where children cannot always escape. The writer tells of his Third Ward neighbors bracing for a possible attack from Canada; he and his friends went to bed with their gun at their side. (Courtesy of the Department of Rare Books and Special Collections, the University of Rochester.)

The former C.P. Woodward House on Sophia Street (Plymouth Avenue) was typical of the finer homes of the ward. Since the publisher of this stereo view was C.P. Woodward, it is reasonable to assume that he and his family are shown on the porch. (MLL Collection.)

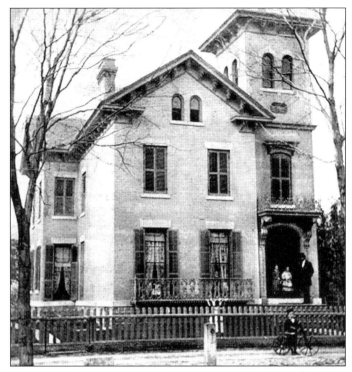

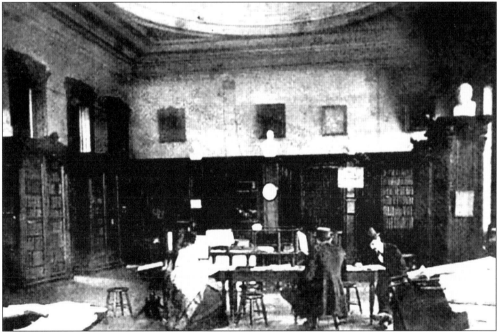

This photograph provides a rare look at the Athenaeum Library in the Reynolds Arcade. The collection later passed to Mortimer Reynolds, who housed it in the Reynolds Library, on Spring Street. The Arcade also housed the main offices of Western Union, where anxious crowds gathered to learn of the major battles. It was on bulletins posted at the Arcade that citizens leaned of the death of Abraham Lincoln.

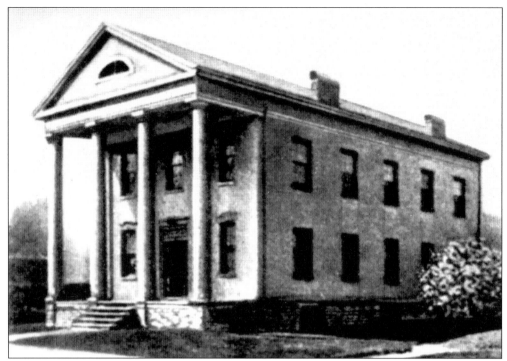

Early settlers built schools as soon as their homes and churches were raised. The schools were privately run before the days of public education. The Rochester Female Seminary opened on South Fitzhugh Street in 1836. The school is also pictured on other pages in various evolutions. (Courtesy of the Rochester Historical Society.)

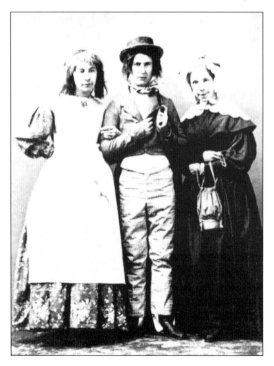

Costume parties and charades were regular sources of entertainment in Rochester society. In this case, Mrs. Montgomery, Levi Ward, and Mrs. Theodore Ives are dressed in clothes of their forebears to raise money at a hospital bazaar in 1863. During the war, Rochester women organized numerous soldiers-aid projects. The same occurred in Southern cities, where the needs were harrowing. A local magazine, the *Soldier's Aid*, detailed the local relief efforts, which included boxing and sending surgical supplies, bandages, and food to the battlefields. (Courtesy of the Rochester Public Library.)

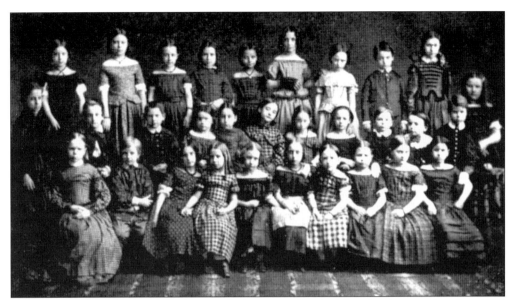

Scholars of the primary department of Araminta Doolittle's school pose for this 1854 daguerreotype. The school was in the seminary pictured on the opposite page. In 1892, Alice L. Hopkins recalled that "females" then were educated "into highbred, courteous, cultivated, truthful women of society, well-dressed, and above all, without eccentricities, trained never to do anything to attract attention." Children of more noted Third Ward families here include Selden, Chapin, Chappell, Backus, and Ely. Boys were later sent to male seminaries. Fourth from the in the middle row is Millicent Backus Alling. (Courtesy of the Rochester Historical Society.)

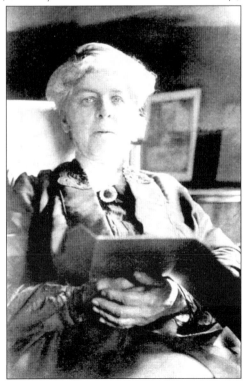

Millicent Backus Alling, pictured above when a child, has a quiet repose much later in life. She was a typical lady of the Third Ward. The Alling House was the scene of numerous social and philanthropic events. (Courtesy of the Rochester Historical Society.)

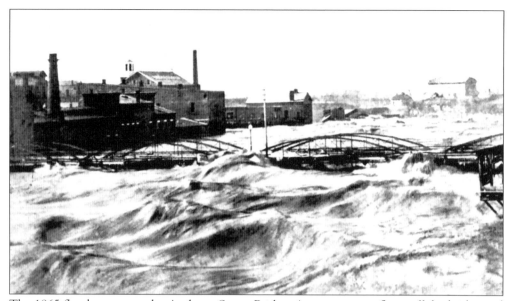

The 1865 flood rages past the Andrews Street Bridge. A streetcar was flung off the bridge and sent over the falls. Foundations beneath mills and factories dissolved from saturation and brought the upper stories crashing down. News of Gen. Robert E. Lee's surrender and the end of the war, in which 650 local soldiers had died, brought relief to Rochesterians as they cleaned up after the flood. However, their joy over the war's end was shattered a week later when they read the posts at the Arcade telling that President Lincoln had been assassinated.

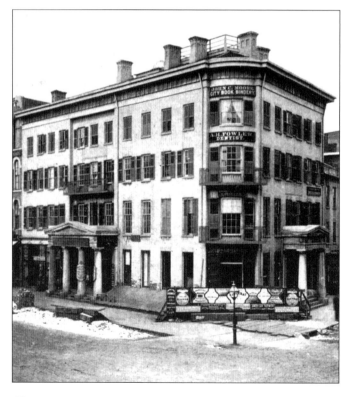

The Eagle Hotel, pictured here c. 1850, stood at the northwest corner of West Main and State Streets. Built in the 1820s, it was a leading Rochester hotel for decades and was leased to several businesses. Citizens complained about its abundance of advertisements. It was demolished after the Civil War to make way for the much anticipated Powers Building. The young writer tells about having a job nearby at 88 State Street. For some minor misdeed a manager "belted me with a strap. I'm going to tell pa." (Courtesy of the City of Rochester.)

There is a tranquil Currier and Ives atmosphere to South Washington Street. The Jonathan Child mansion is in the distance. The first two houses are gone now. The young writer recounts, "A man has got a lot of pigs out Washington Street and we went out there and had some fun. There was a hornits nest in the peak of the pen so you could plug it with rocks through a little window." Near this scene he skated on the canal, played baseball, raced his horses through the ward, fell for pretty girls, blew the door off a neighbor's house, and put glue in the hat of his aunt's gentleman caller. His antics, shocking by current standards, were probably quite typical of boys of the time. Since he kept his journal for 1864 alone, his thoughts on the end of the war are not known.

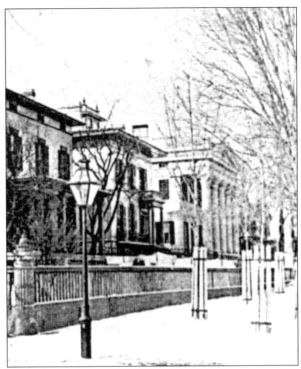

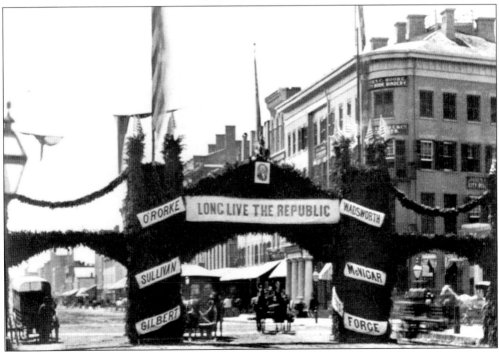

A Civil War victory arch spans the Four Corners during the July 4, 1865 victory parade. It bears the names of local war heroes such as Colonel O'Rorke, a hero of Gettysburg; Sullivan, Forge, McVigar, and General Wadsworth who died from wounds received in the Wilderness Campaign.

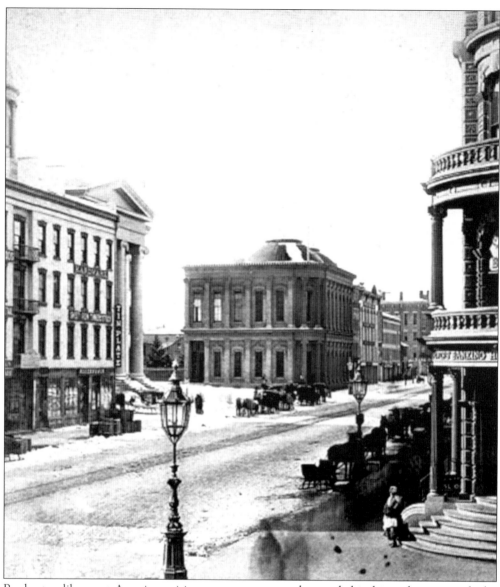

Rochester, like most American cities, was eager to put the war behind it and get on with the future. The prolonged anguish of those years would take a long time to diminish. Many Southern cities and towns were in ruins, and political turmoil, racial issues, and Reconstruction brought discord for decades. This stereo view shows the first completed stage of the Powers Building, on the right. In the center is the first stage of another important architectural accomplishment, the Rochester Savings Bank office, which created a graceful entrance to the ward from the corner of West Main and South Fitzhugh Street. Rochester continued to surpass its early prophesies in startling ways.

Three

LIVINGSTON PARK

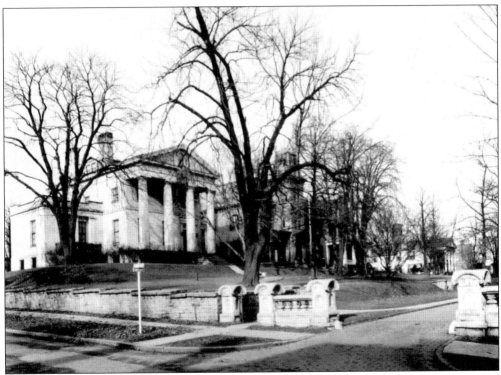

Livingston Park was a fashionable and exclusive gated neighborhood of 10 houses. Originally, a sidewalk circled at the south end and gave access to the park; however, there was no thoroughfare for vehicles. James K. Livingston, after whom the park is named, built the first house in 1834. This view is looking northwest. The homes on this side of the park had a double terrace carved into the hillside. Livingston Park, often known simply as "the Park," was perhaps the most picturesque and romantic setting in the ward, if not the entire city. (Courtesy of the Rochester Public Library.)

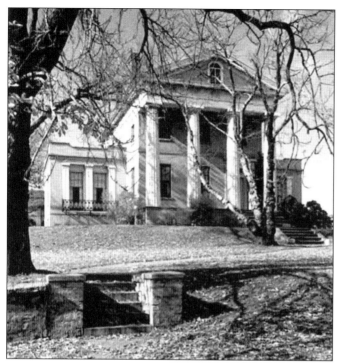

Built in 1837, the Hervey Ely House is the only original structure remaining in Livingston Park. It was designed by S.P. Hastings of Boston, who also designed homes for Jonathan Child and Benjamin Campbell. Flights of steps allowed visitors to descend the terraces to either Troup Street or the oval of turf down the center lane. In 1920, the Irondequoit Chapter, Daughters of the American Revolution acquired the property. This photograph was taken in 1966 by Hans Padelt for the Historic American Buildings Survey. (Courtesy of the Irondequoit Chapter, Daughters of the American Revolution.)

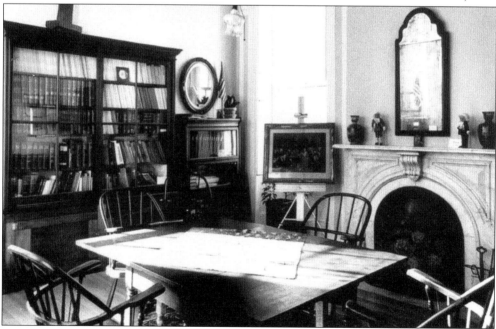

The library of the Ely mansion reflects the simple dignity of the Greek Revival style that was all the rage in Corn Hill. Three styles—Greek, Doric, and Corinthian—reached new levels there. Hervey Ely was an industrious young man of 22 when he arrived in Rochester in 1813. In a mere five weeks, he was ready to open his own sawmill. Col. Nathaniel Rochester's thriving settlement soon had several more—and larger—Ely mills. (Photograph by Frank A. Gillespie, courtesy of the Irondequoit Chapter, Daughters of the American Revolution.)

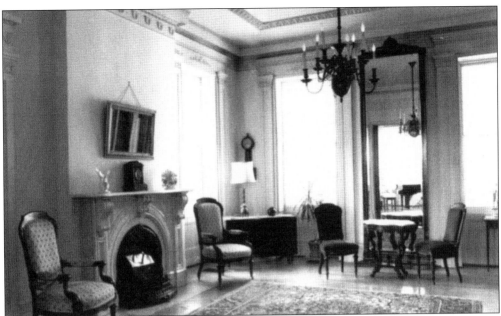

One of the lavish Ely parlors sparkles in this detail from a Frank A. Gillespie photograph. The house has nine richly carved marble fireplaces, 12-foot ceilings and elaborate plaster decorations. The exterior of the house featured stucco applied over brick and stone that was then engraved to resemble cut stone. Hervey and Caroline Ely never had children of their own but were foster parents to at least eight. They lived in the house only four years before the collapse of the flour market forced them to sell it. Through good times and bad, they remained generous to those in need and were among Rochester's leading citizens for nearly 50 years. (Courtesy of the Irondequoit Chapter, Daughters of the American Revolution.)

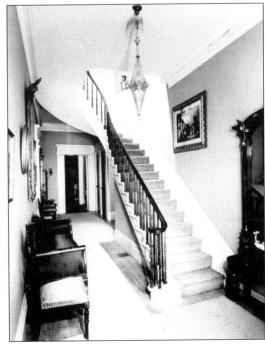

The dignified foyer of the Ely mansion features this 13-foot staircase that curves gracefully to the second floor. Visitors entering the foyer first pass under the soaring 26-foot Doric columns of the front porch. Today, the Daughters of the American Revolution chapter uses the first floor as a museum, genealogical library, and meeting place. Among the artifacts on display is a drum owned by Alexander Milliner of Rochester. When only 16, Milliner joined the Continental army and served four years as a drummer boy in General Washington's Life Guard. Hans Padelt took this photograph for the Historic American Buildings Survey. (Courtesy of the Irondequoit Chapter, Daughters of the American Revolution.)

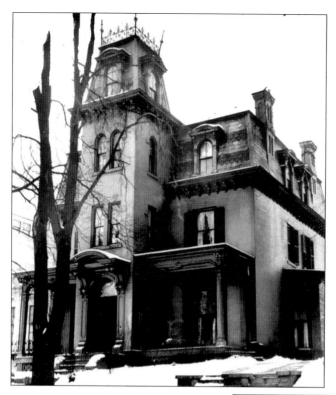

The Elys' neighbors had an equally impressive mansion—the Buell House. Built in 1845 the Buell family lived in the mansion for several generations. George C. Buell was a prosperous grocer, so when the house was opened for New Year's Day visits, as was the tradition of many "old" Third Ward families, youngsters eagerly stopped here for sweet cakes and other pastries. The Buell House was one of five buildings taken down in the 1960s to make way for the Rochester Institute of Technology gymnasium. (Courtesy of the Landmark Society of Western New York.)

This 1860s stereo view shows the Cheney House, at 7 Livingston Park, before it was enlarged. William Cheney, a foundry owner, is credited with planting many of the trees in Livingston Park. The family lived here for five generations. When daughter Carrie was married in 1857, the park was adorned with Japanese lanterns. Prominent Rochesterians were brought to the affair in elaborately decorated rigs and hacks, which were then converted into "chariots of state" lined up along the park. Third Ward weddings were generally major events. Onlookers often followed the wedding party from the church to the reception and sometimes remained on the lawn, peeking in the windows at the well-attired guests dancing beneath candlelit chandeliers.

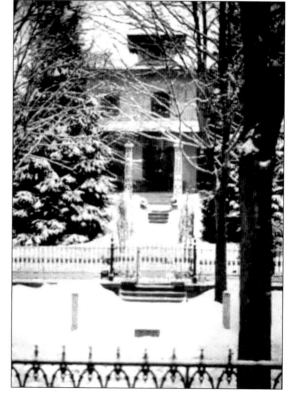

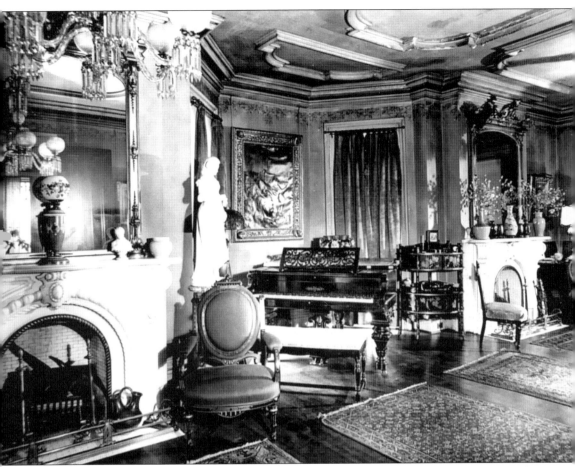

The elaborate interior of the Buell House fully captures the opulence of the gilded age and certainly contrasts with the simple and roomy elegance of the Ely mansion. Each room had a marble fireplace, and the kitchen had a cord-operated bell system used to summon servants in six different tones. Equipped with a hand-operated elevator, the house was the first in the city to be lit with gas lamps. (Courtesy of the Landmark Society of Western New York.)

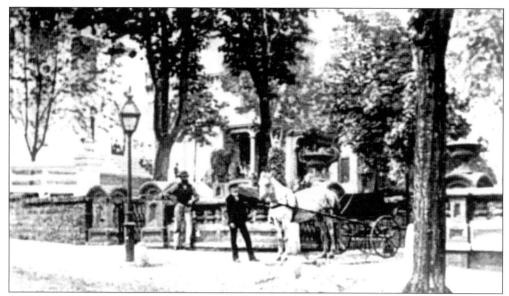

A driver poses with a rig in the opened gateway at the south entrance. Originally there was no southern opening. The elaborate iron gates that eventually opened at both ends were removed in the 1870s and replaced with these Frearstone gates, urns, and pillars. Frearstone was invented by a Rochesterian who claimed it was indestructible. Two other identical sets of gates were located in the city; one set survives today at Arnold Park off East Avenue. (Courtesy of the Landmark Society of Western New York.)

Homes along the east side of Livingston Park were eventually enlarged. The narrow center lane, with the flanking sidewalks, can be seen. There are no driveways—access to carriage houses was from alleyways behind the houses. Many residents preferred to rent their horses and carriages rather than own them. Numerous stables sprang up in the ward as a result. By 1900, the city had an estimated 15,000 horses—enough to generate a fertilizer pile 175 feet high, large enough to cover an acre. Although the introduction of the automobile stressed the ward, it offered welcome relief from the odors, disease, and pollution of horses. (Courtesy of the Rochester Historical Society.)

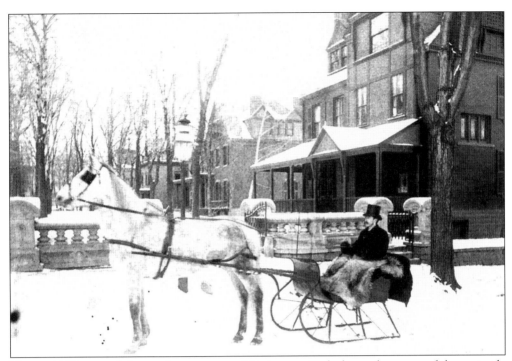

This c. 1900 view of the southeast corner of Livingston Park shows that most of the east side houses have been enlarged. Dr. Edmund Clayton Smith is out for a sleigh ride on Troup Street. The house just behind him was built in 1844 for Horatio N. Fenn, a dentist and druggist. It stood directly across the street from the Daughters of the American Revolution chapter house. (Courtesy of the Rochester Public Library, Local History Division.)

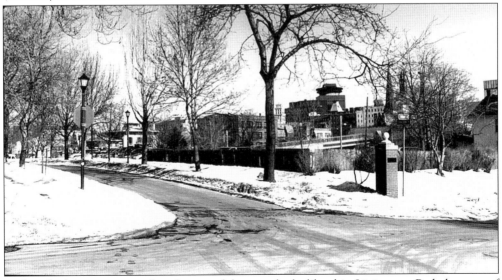

Today, the location pictured at the top of the page looks like this. Livingston Park, because of its isolation, managed to survive well after the Third Ward's social fabric began to fray in the 1880s and the press of the city's industrialization made the northern part of the ward undesirable. The Daughters of the American Revolution house and a well-attended arena are now the sole occupants of the old park.

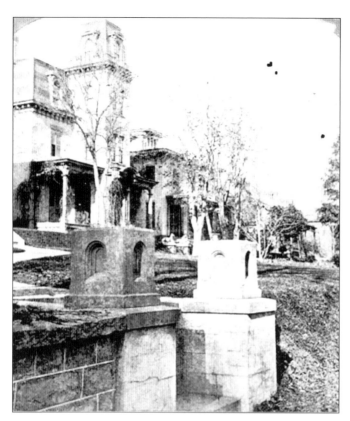

In *Grandfather Stories*, author Samuel Hopkins Adams recounts a childhood visit one New Year's Day to the Buell House. The family had spent the morning visiting homes that were open for refreshments, a holiday tradition. Adams and his family turned their sleigh off Plymouth Avenue and onto Troup Street. "Livingston Park, we had learned, was wide open. Every house on the upper slope was 'receiving.'" Of the Buell House, prominent in this *c.* 1870 stereo view, he writes, "The windows were garnished with holly and a wreath decorated the entry. We toiled up the sloping walk between the snow-festooned rhododendron bushes and pushed open the outer door." (MLL Collection.)

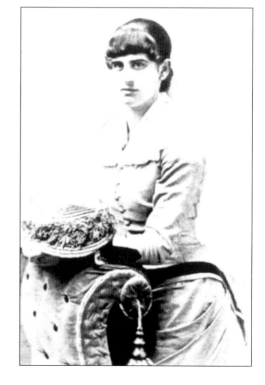

Caroline Balestier of Rochester became the wife of novelist Rudyard Kipling. Her grandparents Anna and E. Pershine Smith lived in a house on Plymouth Avenue near Troup Street and then moved to Livingston Park. Her grandmother Anna was cousin to Sophia Rochester. (Courtesy of the Rochester Historical Society.)

E. Pershine Smith, right, was commissioner of immigrations in Washington, D.C., and as such, was close to the Lincoln administration during the Civil War. He later became legal adviser to the Mikado of Japan. He and his wife, Anna Smith, lived for a time in Livingston Park. They were grandparents of Caroline Balestier, who married Rudyard Kipling. A neighbor, Thomas H. Hyatt, was ambassador to Japan under Pres. James Buchanan. He was remembered for decorating Livingston Park with Japanese idols and lanterns. He often walked through the park with a Japanese umbrella, wearing a Mandarin coat. (Courtesy of the Rochester Historical Society.)

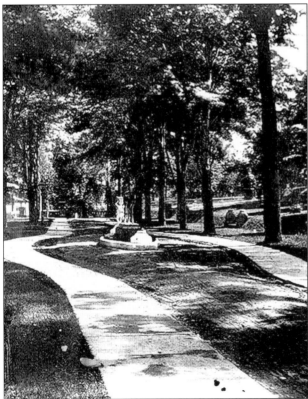

This stereo view, probably from the 1860s, shows shady Livingston Park from its entrance at Spring Street. The center turf was used not only as a road but also for outdoor gatherings and dinners. The sidewalk started at the opened gates on Spring Street and circled the south end of the park. Seneca Indians once occupied this site, and the noted White Dog Ceremony was held just south of Livingston Park. The Iroquois connection continued when Henry Brant Williams built a home on the east side of the park. Williams had been named after family friend Joseph Brant, a famous Mohawk chieftain.

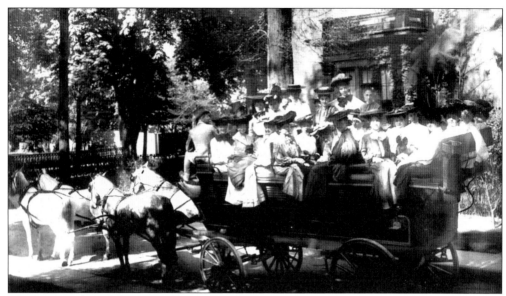

The house at the northwest corner of the park became Livingston Park Seminary. In this *c.* 1904 photograph, seminary students are heading off to the town of Rush for an outing. They are in a Tally-ho pleasure coach, drawn by four horses. The students are dappled in morning light, and the surrounding park is lush. Under close scrutiny, this view toward Spring Street reveals the kitchen wing of the Brewster-Burke House, which is still standing on the corner of Spring and Washington Streets. (Courtesy of the Rochester Public Library, Local History Division.)

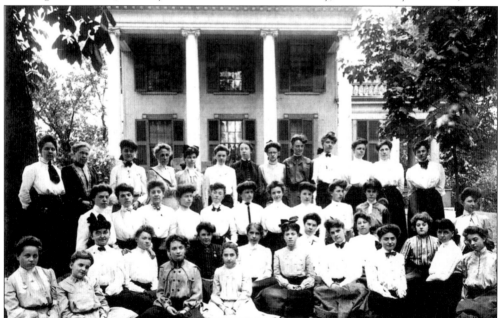

Students and staff of Livingston Park Seminary pose in June 1903. In 1838, Dr. Frederick F. Backus, husband of William Fitzhugh's daughter, bought the house and remodeled it into the beautiful Greek Revival pictured here. In the early 1860s, Philip Curtis and his wife acquired the place, and she operated the seminary until her death in 1892. The seminary remained in operation until 1930. (Courtesy of the Rochester Public Library, Local History Division.)

James K. Livingston, after whom the park was named, owned this site in 1834. In 1852, James K. Chappell built this home on Spring Street; its west lawn faced Livingston Park Seminary. Members of the Chappell family can be seen on the porch. Livingston had ties to the famous Hudson Valley Livingstons of the old patroonship days. His daughter, in fact, returned to the Hudson Valley and married a wealthy man. In his declining years, Livingston went to live with her in her beautiful home overlooking the Hudson River. (Courtesy of the Rochester Historical Society.)

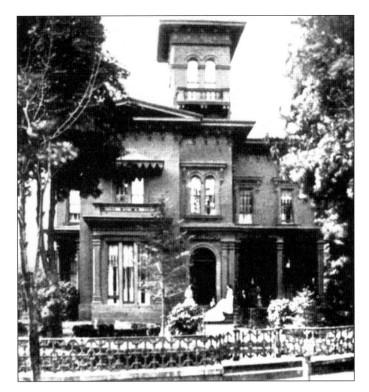

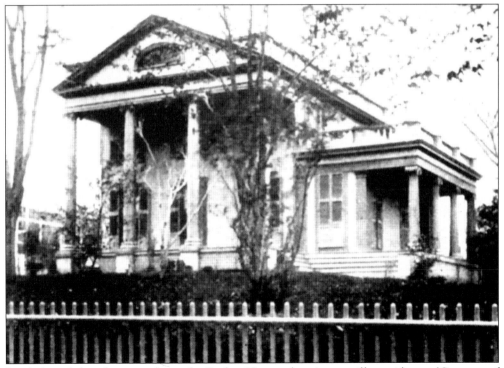

It is believed that this view shows the Backus House when it was still a residence. (Courtesy of the Rochester Historical Society.)

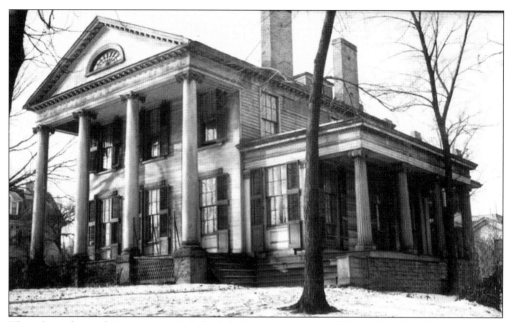

The glory days of Livingston Park had faded by the time Walter H. Cassebeer took this photograph in 1936 for the Historic American Buildings Survey. The once shaded lane now had a paved thoroughfare through it. One by one, the houses were converted first into apartments and then into dormitories; finally, they were demolished. Although the seminary was neglected and slated for demolition, an emerging preservation-minded group recognized its significance. Huge sections of the structure's interior and exterior were cut out and stored for future assembly.

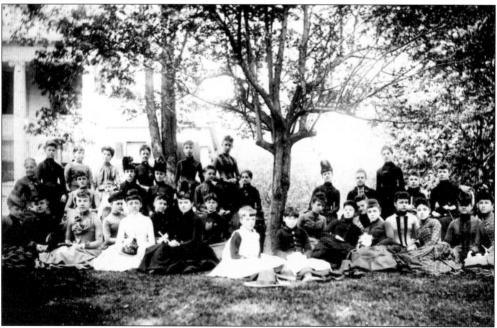

In this 1887 photograph, female students of the Livingston Park Seminary pose on the shady lawn, with the school in the distance. (Courtesy of the Rochester Public Library, Local History Division.)

Every night at 10:00, Livingston Park neighbors would set their clocks by the bell of the nearby Plymouth Presbyterian Church. All socializing would end at that hour, in keeping with the strict traditions of the exclusive park. On some weekend mornings, when the bell's heavy clangs fell through the tall trees, neighbors would gather in the center of the park and take turns conducting devotions. (Courtesy of the City of Rochester.)

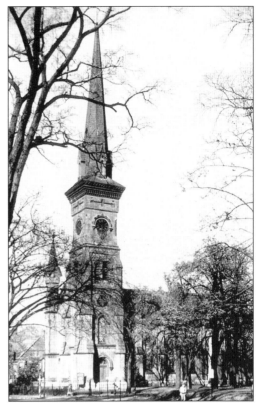

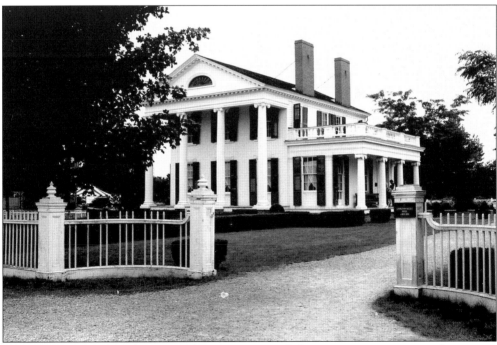

Taken out of storage in the 1970s, the Livingston Park Seminary was reconstructed to appear as it did as a 19th-century residence and was erected at Genesee Country Museum in Mumford.

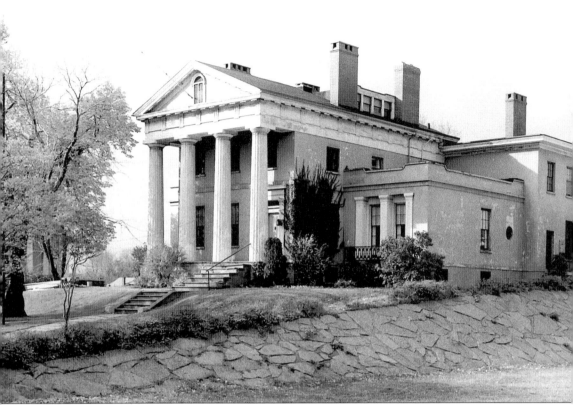

The Ely mansion, now Irondequoit Chapter, Daughters of the American Revolution house, stands as the lone survivor of Livingston Park's residential days. It is a majestic guardian of the laughter, traditions, street dinners, and holiday celebrations. The park was a culture unto itself, a curious blend of Indian legend, "old Rochester" families, Hudson Valley aristocracy, and colorful traits of the Orient. Photographs of gatherings and outdoor activities on the exclusive street, handed down from one generation to another and yet another, are likely scattered to all corners of the country. Few folks are left that have any real memories of when Livingston Park was intact. This compelling photograph, taken in 1967 by Hans Padelt for the Historic American Buildings Survey, shows the actual reshaping of the site. On the right, the double terrace where the Buell House and others including Livingston Park Seminary once stood has been gouged to accommodate a small gymnasium. The east side of the street is now a parking lot. Today, a visitor might contemplate the house and enjoy some sense of what it was like on those long summer days when neighbors rarely imagined that any of it would ever end.

Four

GRANDEUR, DECLINE, AND RENEWAL

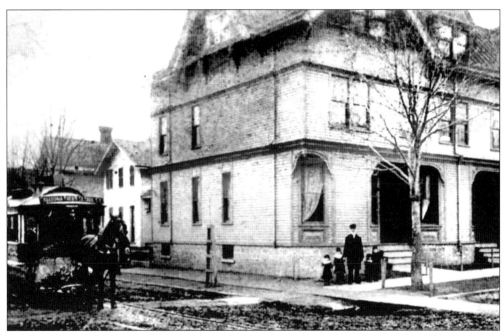

A horse-drawn streetcar lumbers toward the intersection of Caledonia Avenue and Tremont Street on a raw morning sometime in the 1880s. This was known as the Loomis Block because of the number of Loomis family homes in the area. (Courtesy of the Rochester Public Library, Local History Division.)

One of the most picturesque homes in the Old Third Ward was the Chapin mansion, at 110 South Fitzhugh Street. Banker and real estate broker W.W. Chapin and his wife, Elizabeth Lyon Chapin, lived in the home for many years. It was built in 1835 by Edmund Lyon, Elizabeth's father, who also financed the Rochester School for the Deaf. It was noted for its New Year's Day open houses. During the Civil War, the elite danced to waltzes in the ballroom, where a gallery accommodated a small band. It had eight bedrooms, a sewing room, a billiards room, a parlor, a dining room, a library, and a music room. It was demolished in 1957 to make room for the civic center. (Courtesy the Landmark Society of Western New York.)

This early row house stood at the southeast corner of South Fitzhugh Street across from the Campbell-Whittlesey House. Lewis Henry Morgan, a lawyer and ethnologist, lived on the right side from 1855 until his death in 1881. The house was demolished in 1953 to make room for the approaches to the Troup-Howell Bridge. (Courtesy of the Rochester Public Library, Local History Division.)

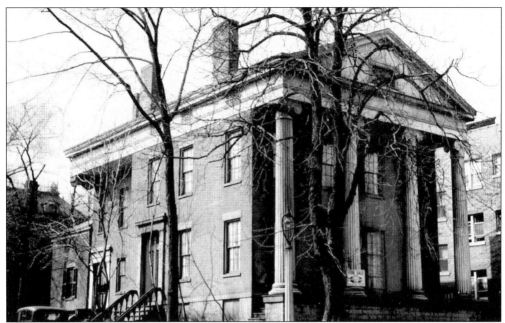

Benjamin Campbell built this magnificent home in 1837. Later owned by the Whittlesey family, the house is nationally regarded as a near perfect example of the Greek Revival style. Plans to demolish it for construction of the Inner Loop were thwarted primarily by the efforts of Elizabeth Holahan, then president of the Landmark Society of Western New York. The Campbell-Whittlesey House is now maintained as a house museum by the society. This view is a detail from a photograph taken by Herb Bohacket in 1934 for the Historic American Buildings Survey.

Some Wardians lamented that the relocation of the University of Rochester from West Main Street to the east side of the city removed the intellectual center of the city from the Third Ward. Yet, Lewis Henry Morgan, author of *The League of the Iroquois,* was the intellectual leader of Rochester from the 1850s until his death in 1881. In his Edwardian library, built behind his Third Ward home, were held some of the most lively debates and discussions of the time. Morgan started the Rochester Historical Society. He was also revered as a friend to the Indians, often interceding on their behalf when he felt they were being swindled.

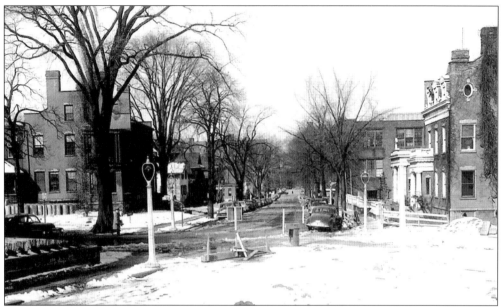

This late-1950s view up South Fitzhugh Street shows that decay and neglect have taken their toll on the ward. The Chapin House, on the right, was still well maintained by the Greek Orthodox Church. The Campbell-Whittlesey House is kitty-corner from it, with the stone foundation for its fence visible in the lower left. The Lewis Henry Morgan row house is already gone, as construction barriers and detour signs for the Inner Loop are being put up. "In its heyday, the Chapin House was a bright jewel in the tiara of the city's social life, for the grandeur of Fitzhugh Street was something to behold in the middle of the 19th century," Bill Beeney of the *Democrat & Chronicle* wrote in 1957. (Courtesy of the Rochester City Hall Photo Lab.)

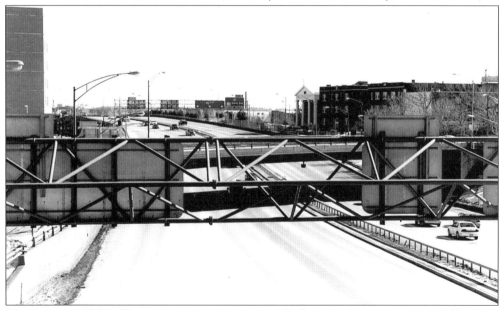

The Interstate 490 and Inner Loop ramps careen noisily through what preservationist Elizabeth Holahan called "the heart of the Third Ward." Just to the right of center is the Campbell-Whittlesey House, and across the highway is part of the civic center.

The First Presbyterian Church was built in 1871 on the corner of South Plymouth Avenue and Spring Street. Designed by noted local architect A.J. Warner, it contains wonderful stained-glass windows by Tiffany. The church continues to house the oldest congregation in Rochester. Fashionable Corn Hill residences extend from both sides in this c. 1900 view. (Courtesy of the Rochester Public Library, Local History Division.)

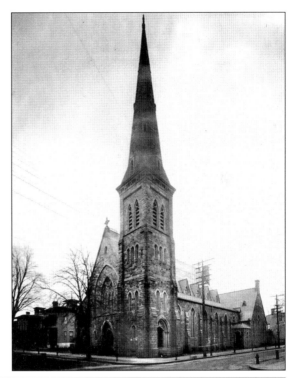

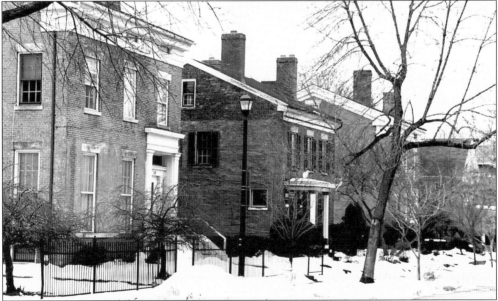

When the sun is just right, Atkinson Street glows with the incandescence of brick homes dating back to the 1830s. Like much of Corn Hill, this street fell on hard times during the 1950s and 1960s. Properties were owned by absentee landlords disinterested in the once unique character of the neighborhood. Homes used as dormitories were subjected to further abuses, such as the time a student rode his motorcycle up and down a staircase. In the 1970s, urban homesteading saved many of these fine residences from further degradations. In this contemporary view, the hard work of devoted restorers is evident.

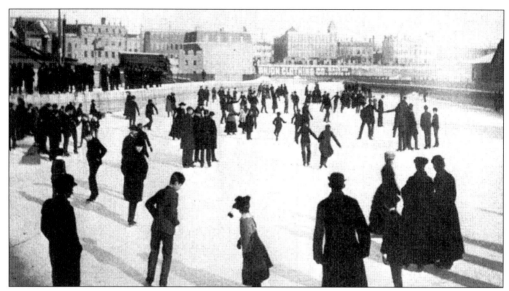

Ice skaters take a turn on the Erie Canal aqueduct *c*. 1880. Before Rochester was a chartered city, the Puritanical New England notions of the pioneers toward social activity discouraged shows of public amusement. The first true generation of Rochester-born young men and women saw things differently. Wealth led to leisure time activities that included both sexes. Although these activities were restrained by strict Victorian codes of conduct, the "old pioneers" were nonetheless dismayed.

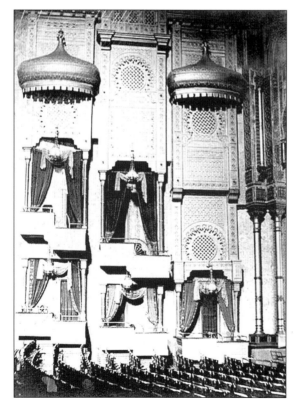

This stereo view shows the exotic interior of the Lyceum Theater, located on the east side of South Avenue, a mere stroll from Corn Hill. As early as the 1850s, the social elite of the ward wished to project the metropolitan culture of the expanding city. With telegraph lines running into the city, along with canals and railroads, the quest for knowledge—especially regarding the latest fashion and entertainment trends—was eagerly sought. In the pioneer days, theater and circuses were scorned. At that time, recreation was limited to meditative strolls through Mount Hope Cemetery or quiet contemplation during a walk through a public garden. Public expression was to be limited to the awe-filled gaze one experienced while looking at the city's spectacular waterfalls. (MLL Collection.)

Buffalo Bill Cody and his family were Third Warders for a time, having a residence on Exchange Street. Cody's boisterous *Wild West Review* was performed outdoors and indoors, including on stage at the Grand Opera House in 1875. His son Kit Carson Cody attended a school headed by Susan B. Anthony's sister Mary. The son died in 1876 from scarlet fever; he is buried at Mount Hope Cemetery, where other Cody children were later laid to rest. Cody's daughter Arta attended Livingston Park Seminary.

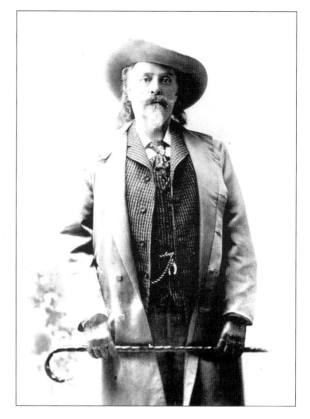

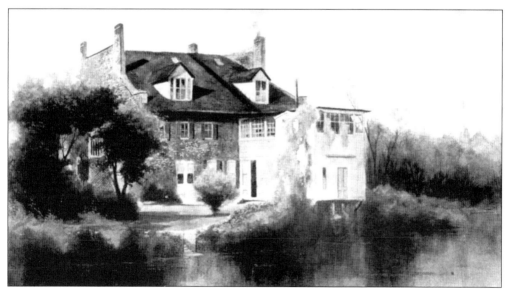

Originally, homes extended to the river. The Jacob Anderson House, depicted here in a c. 1900 painting, was built c. 1844 in a picturesque grove on the east side of Exchange Street, where a raceway intersected with Court Street. In later years, the area became increasingly commercialized with lumberyards, stables, mills, slaughterhouses, and the Genesee Valley Railroad facilities. (Courtesy of the Rochester Historical Society.)

In this fascinating 1854 view looking northwest from Mount Hope, the original 1844 Clarissa Street Bridge can be seen. The canal feeder runs parallel to the river, on the lower right side. Most of Corn Hill is included here. The landscape beside the river is being sculpted to accommodate the expanding Genesee Valley Railroad. Note the Genesee Valley Canal, in the upper left corner, heading west under numerous bridges en route to its junction with the Erie Canal between Trowbridge and Canal Streets. (Courtesy of the Rochester Public Library, Local History Division.)

Elisha Johnson, an astute developer, was responsible for some of Rochester's earliest civic achievements including the Johnson-Seymour race and the Carthage Railroad. He gave the city Washington Square as a gift. In the 1840s, he was chief engineer in the construction of the Genesee Valley Canal. In 1838, Johnson became Rochester's fifth mayor. A restless soul, he moved to Tennessee where he ran a large plantation until his death in 1861.

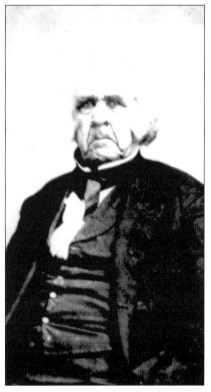

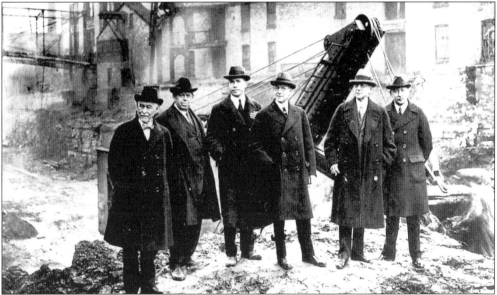

Engineers and city dignitaries stand in the drained prism of the Erie Canal at the beginning of one of the city's largest civic undertakings, the construction of the subway system. The date is April 22, 1923, and the location is between South Fitzhugh and South Washington Streets. The Washington Street canal bridge is visible in the background. The building just beyond it is the corporate office of the Buffalo, Rochester, and Pittsburgh Railroad. The station was several blocks away on West Main Street. (Tom Kirn Collection.)

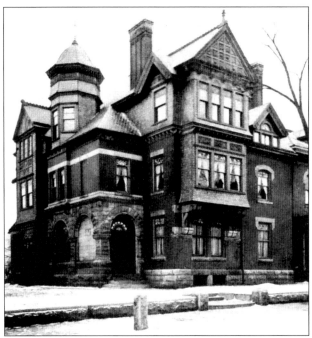

The Yates family owned this substantial home at 130 South Fitzhugh Street. Demolished in 1944, the house stood opposite the Campbell-Whittlesey House. Arthur G. Yates was president of the Buffalo, Rochester, and Pittsburgh Railway. He and his family were prominent philanthropists in the later decades of the 19th century. His wife was known to send out as many as 500 invitations to the social events that she sponsored. (Courtesy of the Rochester Public Library, Local History Division.)

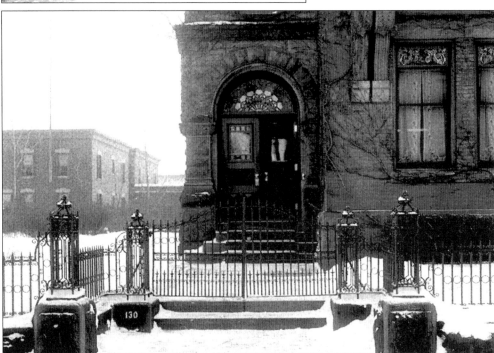

In front of the Yates House, at 130 South Fitzhugh Street, the fabulous ironwork gate stands out against a background of snow in 1912. Craftsmanship abounded in this residence—note the stonework around the door and the beautiful stained-glass windows. What a beautiful section of the ward this intersection of Troup and South Fitzhugh must have been. On one corner stood this home and nearby were the Campbell-Whittlesey House, Hoyt-Potter House, the Henry L. Morgan row house, and the Chapin House. (Courtesy of the Rochester Municipal Archives.)

Tool manufacturer A.M. Badger built this Italianate-style mansion in the 1860s. Situated on Atkinson Street, it was constructed of an unusual yellow brick. After years of wear and neglect, it underwent a major rehabilitation in the 1970s. Since then, it and has since been affectionately referred to as "the Taj Mahal."

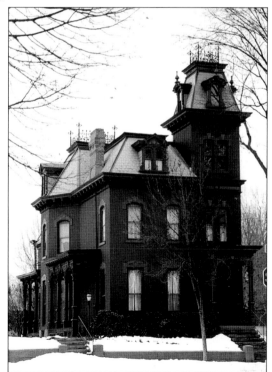

The Second Empire is among the styles represented in the Third Ward. With its iron cresting intact, the Irwin House, at 97 Adams Street, still stands as straight as when it was built in 1866. Demolition crews used to complain about how difficult it was to bring down such handcrafted structures.

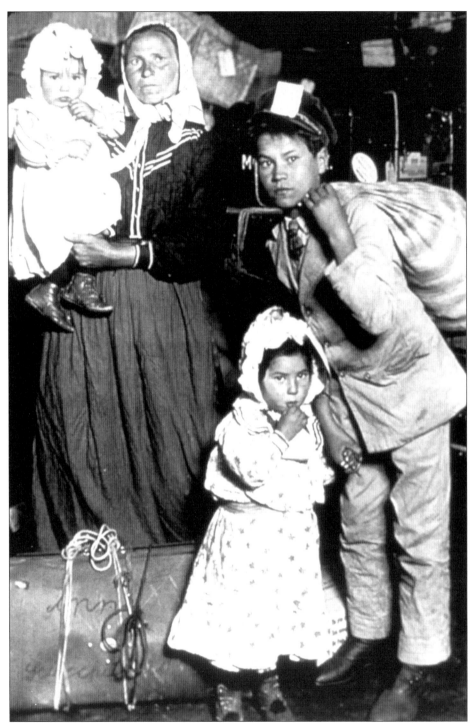

An immigrant family arrives in Rochester, seeking the American dream. The family members will likely be housed in an ethnic neighborhood where continued practice of their traditions will lessen their homesickness. Corn Hill had its own international flavor, with several small ethnic neighborhoods. (Courtesy of the Rochester City Hall Photo Lab.)

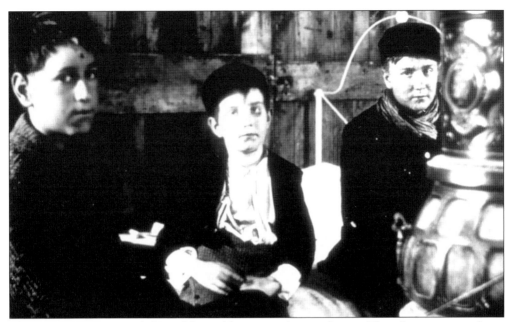

Three young patients inside Hope Hospital keep warm by a coal stove. Their faces express sadness. Located south of the ward on the east side of the river, the makeshift hospital, comprising flimsy buildings, was used to quarantine patients during outbreaks of highly contagious diseases. Women of the ward organized the Rochester Orphan Asylum on Hubbell Street to care for abandoned and sick children. In 1901, a disastrous fire killed 31 children and two assistants. To avoid anything like that happening again, the new facility, called Hill Side, was built outside the ward and incorporated several disconnected buildings. (Courtesy of the Rochester City Hall Photo Lab.)

Philanthropic movements were established in this house, on the southwest corner of Spring and South Fitzhugh Streets. The University of Rochester and the Rochester Female Charitable Society (1822) were founded. The latter's primary objectives, "relieving indigent persons . . . in cases of sickness and distress, and establishing a Charity School," were accomplished. The society also brought about the City Hospital. The family names of women active in social reform include Whittlesey, Alling, Livingston, Perkins, Bronson, and Rochester. The house, built in the early 1820s for *Rochester Telegraph* publisher Everard Peck, was torn down in March 1929. (Courtesy of the Rochester Historical Society.)

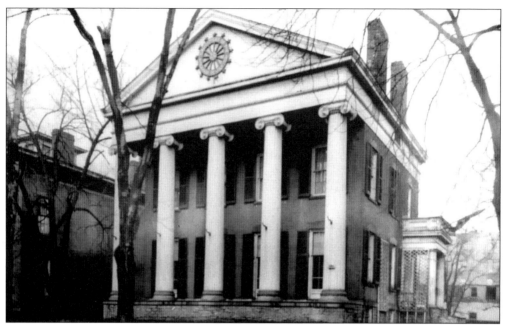

The Montgomery House, built c. 1835 at 160 Spring Street, was considered one of the finest Greek Revival homes in the ward. The Irondequoit Chapter, Daughters of the American Revolution used it for a chapter house prior to 1920 when it acquired the Ely mansion in Livingston Park. (Courtesy of the Irondequoit Chapter, Daughters of the American Revolution.)

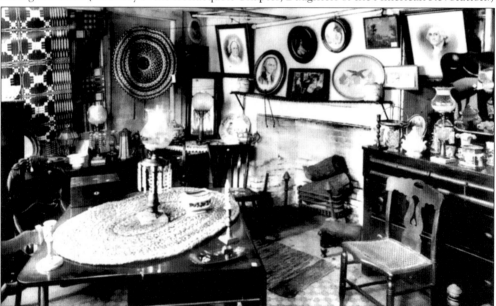

Members of the Daughters of the American Revolution used the Montgomery House as a meeting place and office. They also used it for a soup kitchen and for the Women's Exchange. Shown in what was likely the original back kitchen are household items accumulated by the women and sold to raise money for needy families. Note the open hearth, of interest because early families cooked on open fires; later families updated to cast iron stoves. (Courtesy of the Irondequoit Chapter, Daughters of the American Revolution.)

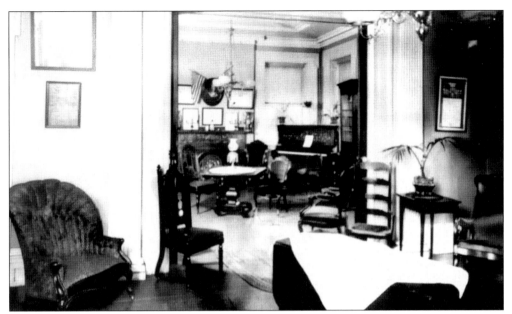

This rare World War I–era view shows the front parlors of the Montgomery home in use as a chapter house. During the war, members of the Daughters of the American Revolution organized dances for the soldiers, a practice that was later taken over by the USO, which gradually expanded entertainment for enlisted men. (Courtesy of the Irondequoit Chapter, Daughters of the American Revolution.)

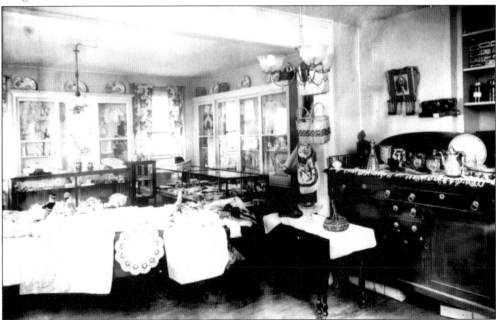

This view shows the Women's Exchange, a charitable cause that was later taken over by churches. The merchandise was for sale to raise money for the needy, especially families of soldiers off to war. These items, considered expendable by those who donated them, were usually low priced. A closer look shows items that would brighten the eyes of any antiques dealer today. (Courtesy of the Irondequoit Chapter, Daughters of the American Revolution.)

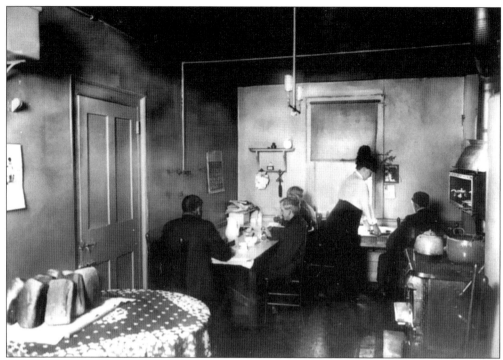

The chapter ran a soup kitchen for those down on their luck. Shown is a chapter woman serving meals in the kitchen. Note the piles of bread on the table and the gas kitchen lamps. With its wood-burning oven on the right, this was a modern Third Ward kitchen for its day. Pictured below is an upstairs bedroom. (Courtesy of the Irondequoit Chapter, Daughters of the American Revolution.)

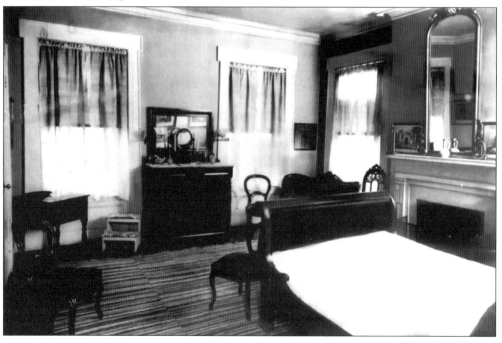

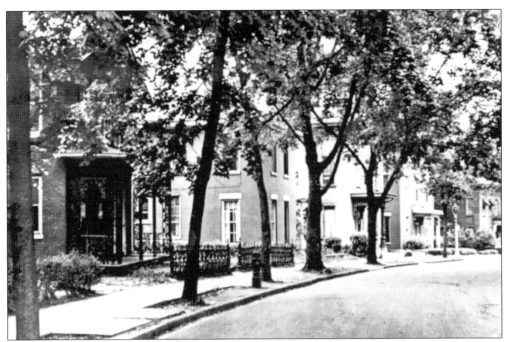

A curve along South Fitzhugh Street, pictured in the 1950s, shows a desirable residential street. Some of the original ornamental iron fencing remains to this day. (Courtesy of the Landmark Society of Western New York.)

This contemporary photograph of the curve along South Fitzhugh Street shows how large the houses are. The masonry Italianate style was popular in Corn Hill. The style is not monotonous because each house features slight variations. These homes have been beautifully rehabilitated within the Corn Hill Preservation District. They are used today as residences and offices.

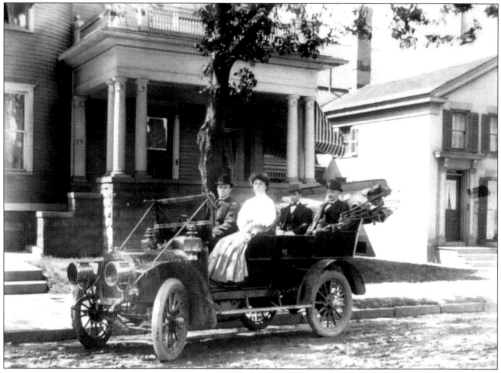

Cora Miller poses with her father, Anthony Miller, and a brother in the family's Cunningham automobile in front of their Atkinson Street home. Cora Miller lived here until her death in 1984 at the age of 94. The current owners of the house are dedicated to preserving the unique interior, which is virtually unchanged from 1895. The kitchen was incorporated from the previous Miller House, pictured below. Original hand-painted canvas ceilings and chandeliers that worked with electricity—or gas when the electricity failed—still grace the twin parlors. (Courtesy of the Landmark Society of Western New York.)

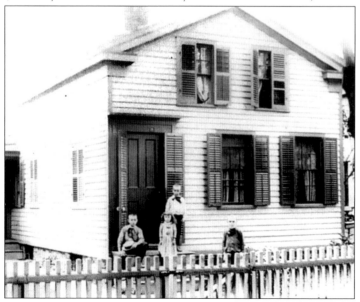

This was the original Miller House. The family lived here until prosperity allowed for the construction of a beautiful Queen Anne on the same site. Owner Anthony Miller was a successful brewer. (Courtesy of the Landmark Society of Western New York.)

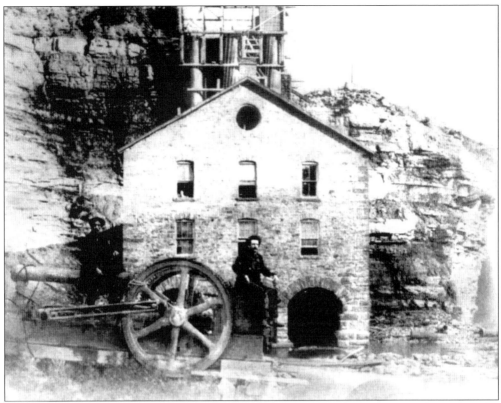

This is one of the nation's first power stations for generating electricity. It was located in the gorge beside the lower falls. (Courtesy of the Rochester Municipal Archives.)

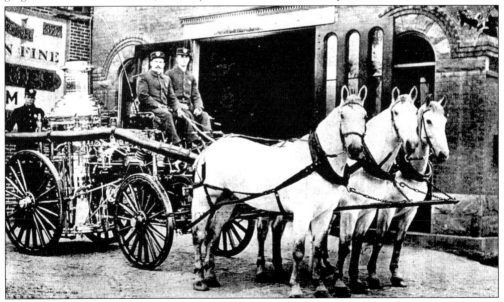

When a fire broke out, steam-powered fire engines like this would race to the scene. Hose Company No. 7, pictured here c. 1900, was located on Plymouth Avenue south of Clarissa Street. (Courtesy of the Rochester City Hall Photo Lab.)

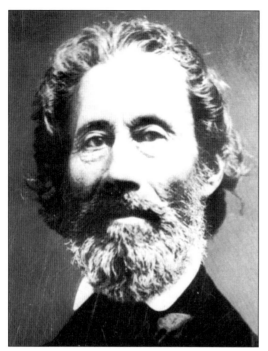

Rochester pioneer Abelard Reynolds projects a quiet dignity in this 1850s daguerreotype. He and his wife, Lydia Reynolds, braved the treacherous New York wilderness to carve out an existence in the fledgling settlement that would become Rochester. Upon their arrival in 1813, they built the first frame house on the 100-acre tract on the site of the Reynolds Arcade. The house later served as a tavern, an inn, and a post office, as Reynolds was appointed first postmaster of Rochesterville.

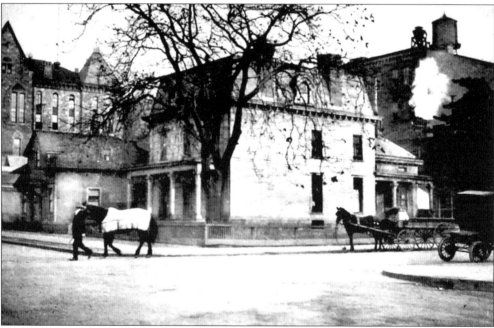

The Fitzhugh House is interesting because it shows how the commercial blocks around the canal and river soared to great heights, overwhelming the once continuous residential streets that ended at Main Street. This is what pioneers like the Reynolds family imagined. Located on the corner of Spring and South Fitzhugh Streets, the house was built in 1822 for Col. William Fitzhugh's daughter. Prepared for demolition in this c. 1915 photograph, the house served as a military school from 1859 to 1862. (Courtesy of the Rochester Public Library, Local History Division.)

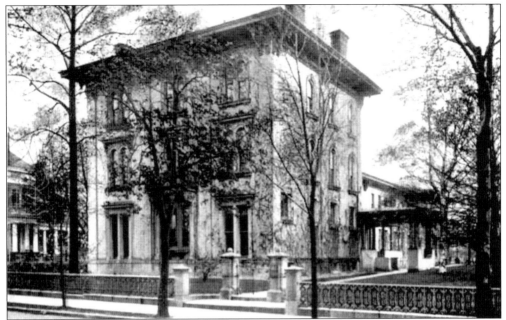

Mortimer Reynolds, son of Abelard and Lydia Reynolds, bought this house in 1877 and lived here until his death in 1892. The Reynolds Library was moved here from the Reynolds Arcade and was later transferred to the Rundel Memorial Building. Located on Spring Street between the Brewster-Burke and Montgomery homes, the house faced the entrance gates to Livingston Park. The side entrance to the Montgomery House can be seen on the right. The mansion was acquired by the Rochester Institute of Technology in 1940 and was later razed, along with other houses on Spring Street, for construction of the Inner Loop. (Courtesy of the Rochester Public Library, Local History Division.)

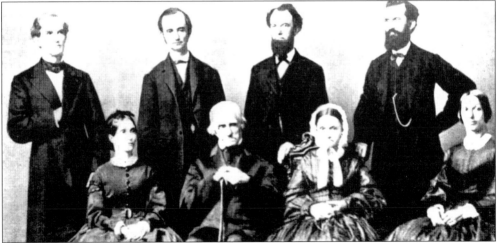

Shown in 1865 on their golden anniversary, Jehiel and Delia Barnard, seated in the middle, worked tirelessly to bring about many community improvements. Delia Barnard was a member of another pioneer family, the Scrantoms. Arriving in 1812, Jehiel Barnard opened a tailor shop near the Reynolds House. He was a singer and bassoonist in a band that performed in Abelard Reynolds's tavern. Barnard died at his son's house on Exchange Street less than a month after this photograph was taken. (Courtesy of the Rochester Historical Society.)

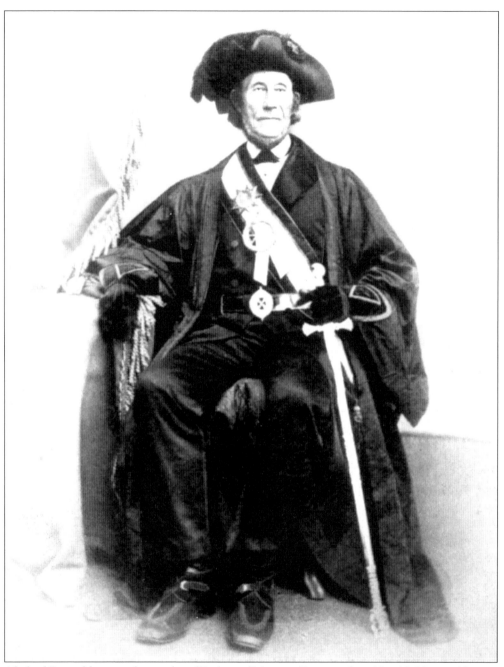

Abelard Reynolds wears the regalia of Prelate of Monroe Commandery, No. 12. He was 83 years old when this photograph was taken on October 2, 1868. From an almost animal-like existence that first year in 1813 when he and h is wife, Lydia Reynolds, arrived, the couple worked hard to establish a fitting home for their future children and to initiate public works and institutions upon which Rochester could grow. They built an impressive arcade, known as Reynolds Arcade, on the site of their home and tavern. The family moved to several homes in the area, including one on South Fitzhugh Street, where Reynolds died in 1878. (Courtesy the Rochester Historical Society.)

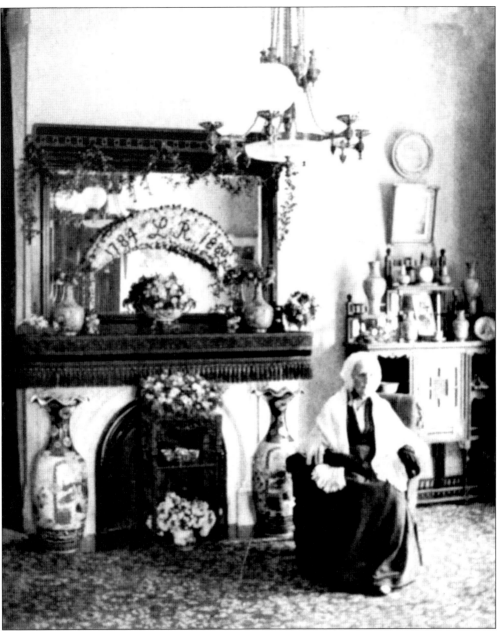

Lydia Reynolds is pictured on the occasion of her 102nd birthday in 1886. In her time, she heard George Washington give a speech and saw Rochester grow from a trampled clearing to a metropolis complete with electric trolleys. Pioneer life agreed with her. In their home and tavern, she oversaw her husband Abelard Reynolds's postmaster business, raised six children, served travelers, and even did some sewing for Jehiel Barnard, the tailor next door. In this picture, she seems indifferent to the opulence around her. Perhaps she is missing her husband and the challenges of the pioneer days. Some records indicate she lived to 104. It is believed this photograph was taken in her son Mortimer Reynolds's house, on Spring Street.

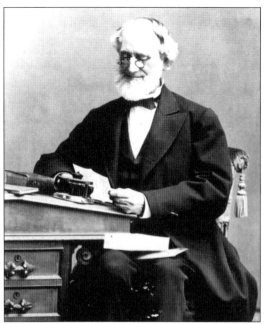

William Reynolds, son of Abelard and Lydia Reynolds, carried on the family's tradition of civic enterprise. He built the Athenaeum building behind the Arcade. It housed Corinthian Hall, a lecture and concert hall. An abolitionist, Reynolds rented the hall to like-minded speakers. Among the most noted speakers were Frederick Douglass, William Seward, Ralph Waldo Emerson, and Susan B. Anthony. (Courtesy of the Rochester Public Library Local History Division.)

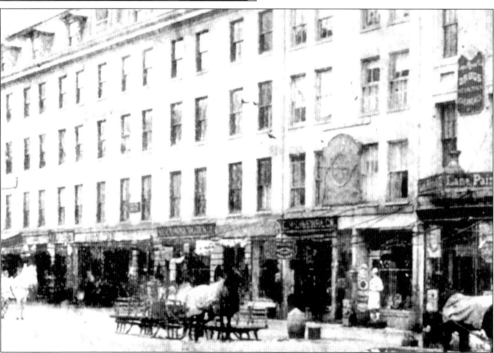

Reynolds Arcade was to Rochester what Independence Hall was to Philadelphia: a meeting place and center of communications. Abelard Reynolds, a sensible businessman, built in 1828 what citizens proudly called "our Arcade." The decorative structure, pictured here in the 1860s, cost $30,000 and became one of the attractions of western New York. In 1856, Hiram Sibley and Ezra Cornell consolidated telegraph operations into Western Union and put their central office in the Arcade. Ellwanger and Barry Nursery Company grew from a location within the Arcade as well. (Courtesy of the Rochester Public Library, Local History Division.)

This is how Rochester looked from near the Reynolds Arcade in the early 1870s. The view is west, and the dome of the courthouse is visible, as is Rochester Savings Bank, on the corner of South Fitzhugh Street. Romantic and sometimes charming cityscapes from that era tend to mask the lingering trauma of the Civil War. While many Southern cities lay in ruins, this image projects a sense of order and a determination to get on with things.

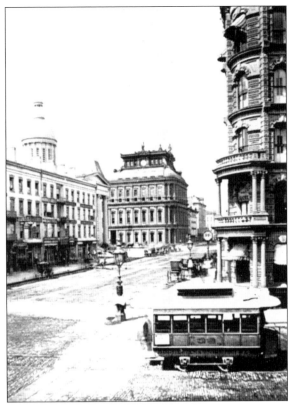

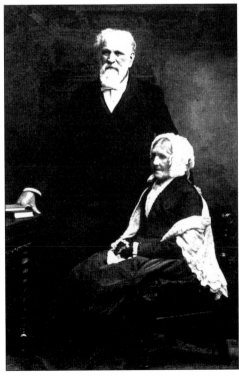

Lydia Reynolds poses with her son William Reynolds *c.* 1886. (Courtesy of the Rochester Historical Society.)

Citizens celebrate the end of World War I. The sign reads, "We got the Kaiser in the cage." Taken at the intersection of South Washington and Spring Streets, this photograph shows the Brewster-Burke House, in the right background, which is still standing. (Courtesy the Rochester City Hall Photo Lab.)

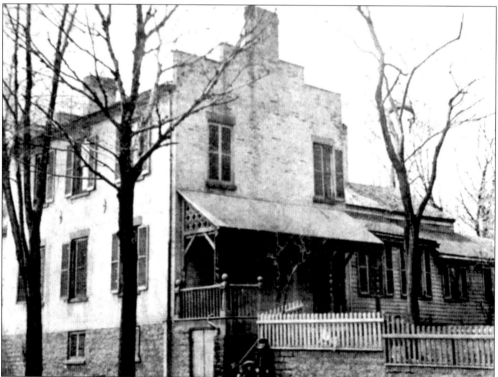

Col. Nathaniel Rochester built several homes for his family around this intersection of South Washington and Spring Streets. This house was built in 1824 on the northeast corner. Records show it was in disrepair by 1895 and was taken down c. 1910 to make way for the Bevier Building. Spring Street was named for an underground spring along its route. During the 1820s and 1830s, some residents took advantage of the spring by enlarging their wells and selling water to nearby businesses. (Courtesy of the Rochester Public Library, Local History Division.)

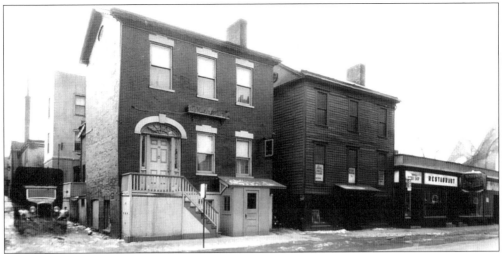

These two small structures on the corner of Spring Street and School Alley were taken down to make way for the civic center. Built as homes in the 1820s, they exhibited remarkable craftsmanship. The front door of the Bicknell House, on the left, now graces the Phoenix Building in Pittsford. The house on the right, also brick, was clad in clapboards at some point. For years, it was the House of Foran Tavern, and the basement housed Humphrey's, a nationally known used bookstore. (Courtesy of the Landmark Society of Western New York.)

The Bevier Memorial of the Rochester Athenaeum and Mechanics Institute stands near the site of Col. Nathaniel Rochester's house. Designed by Claude Bragdon, it features a colorful tiled entrance. To the right is home of Thomas Rochester, the city's sixth mayor. Between the two buildings is the 200-foot spire of the Plymouth Congregational Church, later the Spiritualist Church. (Courtesy of the Rochester Public Library, Local History Division.)

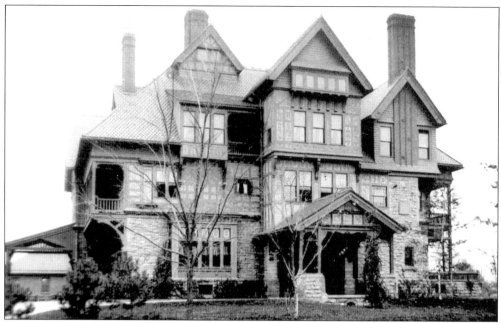

The grandest mansion of all was Kimball's Castle, a pretentious 30-room replica of a Swiss chalet. One of only two homes in the world designed by Louis Tiffany, it was built in 1882 on the corner of Troup and Caledonia (Clarissa) Streets by tobacco magnate William S. Kimball at a cost of $500,000. The city had never seen anything like it. Many Wardians felt it was too lavish when contrasted with the simple elegance of surrounding mansions. The house was nationally known, having been featured in many architectural publications of the day. (Courtesy of the Rochester Public Library.)

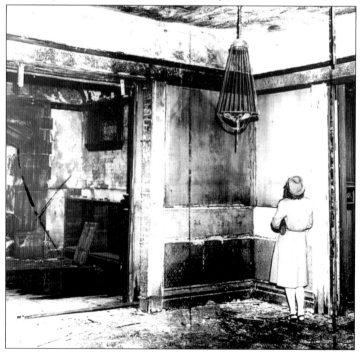

The Kimball mansion closed after William Kimball's wife died in 1922. The rooms averaged 20 by 25 feet, with 15-foot-high ceilings. The brick stables had a carriage elevator. The mansion went through a succession of owners who were unable to keep it up. It had a renowned art gallery and a greenhouse that housed the finest collection of orchids in America. The house is shown stripped of its treasures just before it was razed for a parking lot. (Courtesy of the Rochester Public Library.)

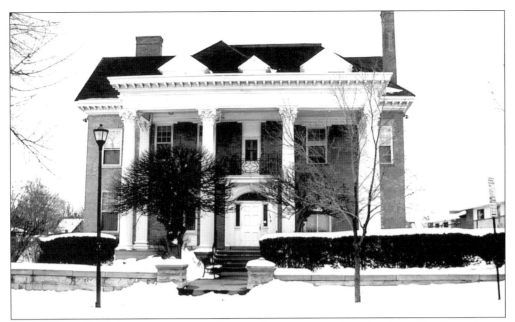

The Kimballs had this mansion next door ready to receive their daughter Cecelia and new son-in-law after a wedding so extravagant it was talked about for decades. The mansion still stands on Troup Street across from Livingston Park.

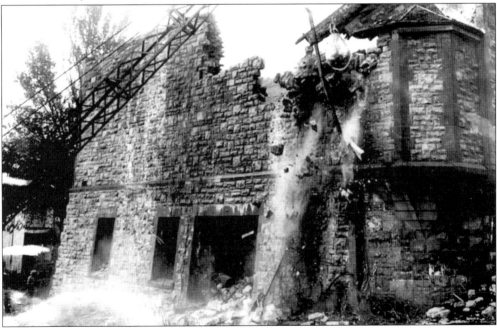

Kimball's Castle, which required 20 housekeepers and groundskeepers to maintain, receives a blow from the wrecking ball. A parking lot and then a small apartment complex later occupied the site. An abundance of mansions line East Avenue and hardly turn heads. Kimball's Castle was a bit overstated for its neighborhood, but its legend endures in the lore of the Ruffled-Shirt Ward. Recently, a desk from the mansion was sold to a buyer in Japan. (Courtesy of the Rochester Public Library, Local History Division.)

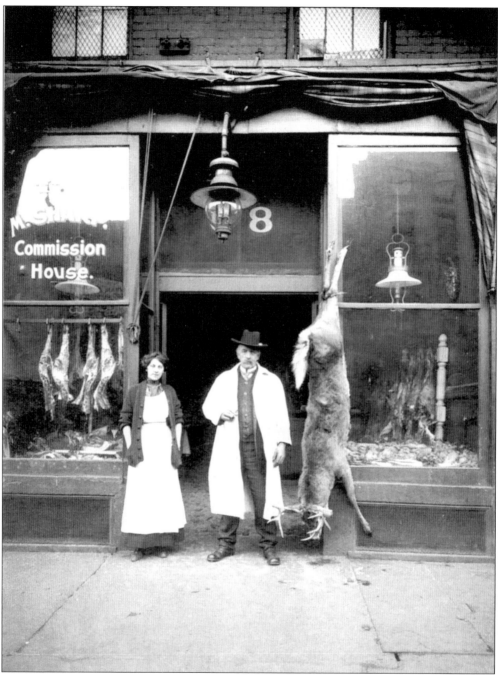

When the lady of the house requested lamb, beef, pork, or poultry for dinner, a servant might be sent over to Front Street for a visit to Sharp's Commission House. Mr. and Mrs. Sharp stand in the doorway, beside a deer that was probably brought in by a hunter for processing. Farmers brought their livestock here to be cut up. The Sharps would take a commission on what was sold. (Courtesy of the Rochester Public Library, Local History Division.)

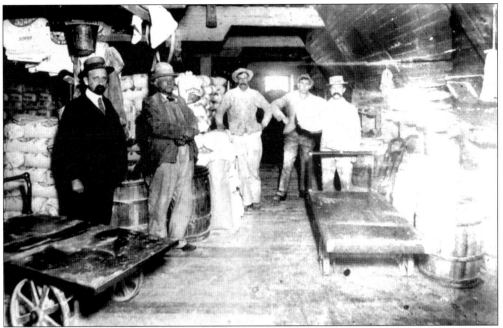

This rare interior view shows the owner and some workers inside the confines of the packing and storage area of the Fast Train Flour Mill, on Browns Race. Some proprietors of race mills and manufactories moved to a small but elegant residential neighborhood near the milling complex, but many chose to remain in their Corn Hill homes. Working here was dangerous business: the air was thick with flour dust, and the deep cellars were cold, damp, and poorly lit. (Courtesy of the Rochester City Hall Photo Lab.)

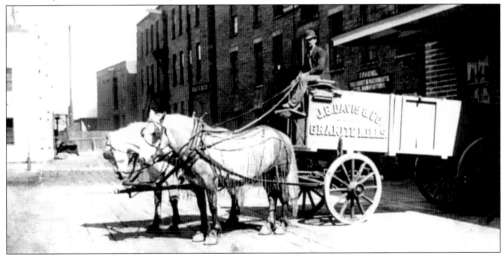

A delivery wagon pulls out of the Granite Mill, at Brown's Race and Platt Street, c. 1904. Fortunes were made and lost in the milling business. Losers rarely stayed down long, however, as there were numerous ways to accumulate wealth. Silversmiths and blacksmiths, for example, developed machine shops that grew into worldwide enterprises. Tailors with small storefronts sometimes grew their businesses into thriving industries that employed hundreds. Industrial Rochester produced many inventions that improved lives around the world. (Courtesy of the Landmark Society of Western New York.)

Two of the Fox sisters professed to be psychics who could communicate with the dead. From left to right are Margaretta, Catherine, and Leah Fox, the older sister. The two younger sisters brought their phenomenon of tapping messages from the dead to Rochester, where they found a willing audience ready to lay down money for readings. They were actually frauds who cruelly preyed on the bereaved. They mastered a technique of snapping their toes and other joints during séances that were known as the Rochester Rappings. They told customers the sounds were coming from their lost loved ones. The sisters began a movement that developed into modern Spiritualism. They operated from the former Plymouth Congregational Church.

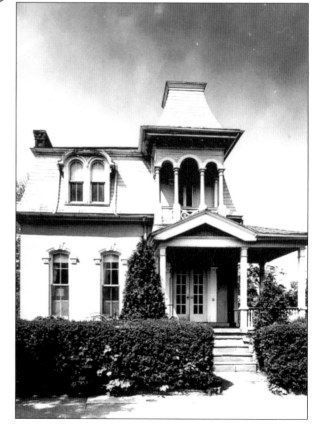

The lovely house at 157 South Plymouth Avenue came down shortly after Hans Padelt took this photograph in 1968 for the Historic American Buildings Survey. South Plymouth Avenue traversed the length of Corn Hill and became North Plymouth Avenue after crossing West Main Street. It remains a long avenue through Rochester's history, telling stories of canals, the river, simple homes and grand mansions, schools, blacksmith shops, grocers, and industries. Settlers connected and eventually widened and paved portions of a trail Seneca Indians had worn along the river. The sections were variously named Hart, Jones, Sophia, and Caledonia before they were connected into a single route called North and South Plymouth Avenue. (Courtesy of the Landmark Society of Western New York.)

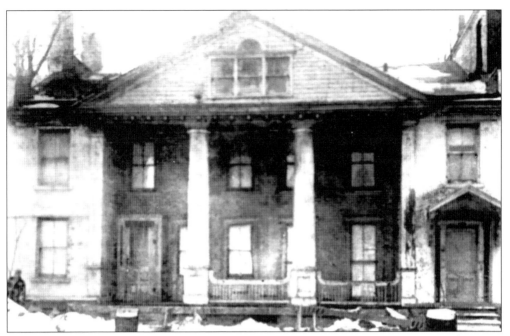

In the early 1850s, the Fox sisters lived at 169–173 South Plymouth Avenue, across the street from the Spiritualist church they founded. Later, the house served as a stop on the Underground Railroad. The building seems suitably creepy, in the tradition of the sisters' spooky practices. In 1956, it was torn down, along with the church, to make way for the Inner Loop. (Courtesy of the Rochester Public Library.)

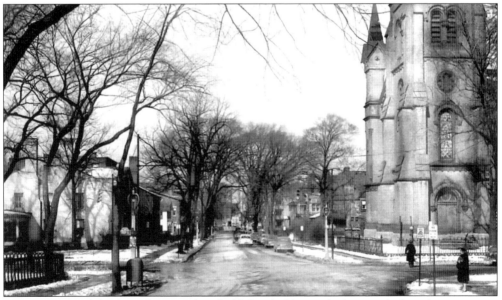

This was one of the last photographs of old South Plymouth Avenue before the street was reworked through Corn Hill in the 1950s. The view is north from Troup Street. On the right is the Spiritualist church. Across the street is the Fox sisters' house. Construction and detour signs were set up shortly after this photograph was taken. (Courtesy of the Rochester Municipal Archives.)

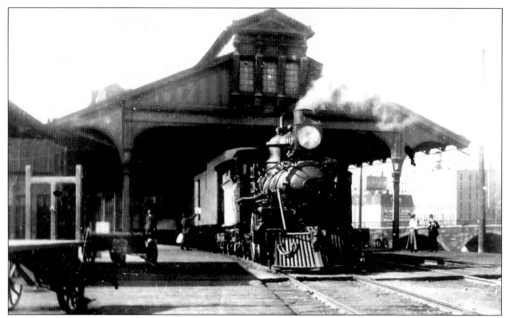

A passenger train prepares to leave the Erie Depot in this *c.* 1910 image. The Genesee River is on the right. The Erie railroad yard was a sprawling complex of storage tracks, a roundhouse, repair shops, and warehouses between the river and Exchange Street. It was originally filled with lumberyards, chandleries, factories, and even a canal stable that was later incorporated into a railroad shed. In the early days, children would sled down a nearby slope they called Bunker Hill, their momentum carrying them onto Exchange Street. (Courtesy of the Rochester Municipal Archives.)

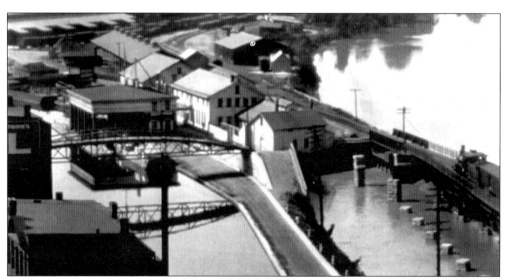

A passenger train leaves the Lehigh Valley platforms on the east side of the river. This early-1900s southward view between the river and South Avenue shows the Erie Canal heading south from the aqueduct. The building just beyond the bridge is the weight lock, where canal boats were weighed to determine freight charges. In later years, the subway system ran through here.

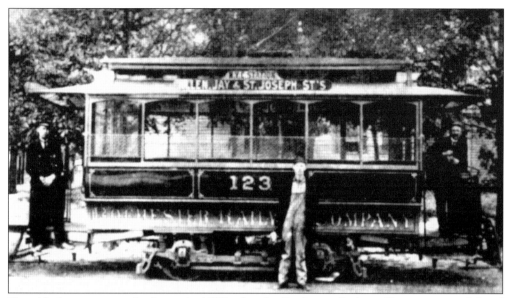

Electrified streetcar service began in 1890, after the Rochester Railway Company consolidated the Rochester City and Brighton Railroad and several other horsecar lines into a single system. Many of the old horse-drawn cars were fitted with new trucks (wheel assemblies) and motors. Electricity was conveyed to the motors through a pole on the roof that came in contact with an electrified overhead wire. A close look shows this car's trolley pole.

George B. Selden, a Third Warder, patented the automobile in 1895. Burdened with patent-infringement lawsuits by the Ford Motor Company, Selden went forward with production of his new vehicles in 1908. At the same time, another Rochester coach maker, Cunningham, began manufacturing automobiles. Cunningham's carriage and auto factory was between Canal and Litchfield Streets, conveniently located near the Ohio basin on the Genesee Valley Canal and the Tonawanda Railroad yard. With the Third Ward just a few blocks away, many young men found employment at the factory. Though the invasion of the auto disturbed the "pace" of the ward, Wardians still happily indulged themselves in the exquisitely handcrafted vehicles, such as the Cunningham pictured here. (Courtesy the Rochester City Hall Photo Lab.)

This tranquil winter view, taken in 1912, shows fencing on South Plymouth Avenue. This scene is vastly different today: the porch on the first house is gone, and the house just beyond, originally the *c.* 1886 McAlpine residence, was converted into the Wilmot Apartments, pictured on the opposite page. (Courtesy of the Rochester Municipal Archives.)

A contemporary view of the elaborate columns of the Wilmot shows how dramatically the original McAlpine residence was altered *c.* 1914, when another story and three massive porches were added.

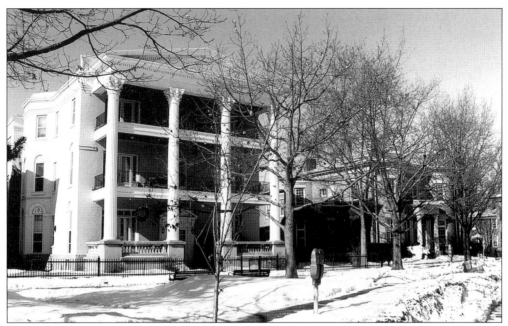

The old Wilmot is bathed in winter sunlight in this contemporary photograph of South Plymouth Avenue. To the right are the bay windows of the Bronson House.

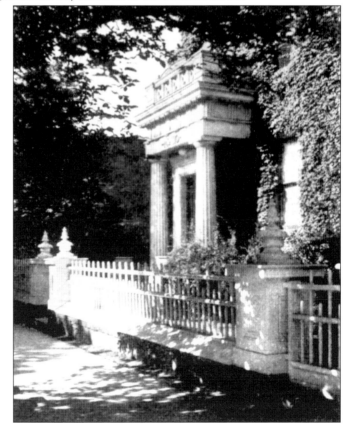

Beautiful handcrafted fences were a trademark of the old ward. One of the most picturesque fences graced the front of the Chapin House, on South Fitzhugh Street. The house is mentioned in *Grandfather Stories*, by Samuel Hopkins Adams, whose family stopped here one New Year's Day.

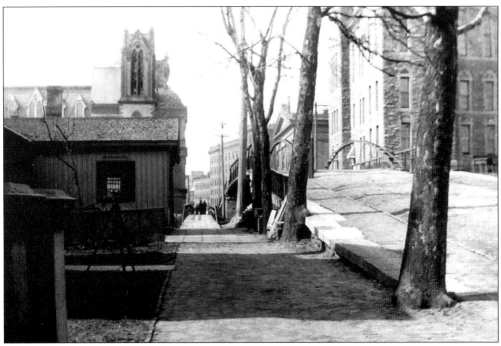

This photograph of the South Fitzhugh Street Bridge over the Erie Canal was taken April 26, 1893. Virginia Jeffrey Smith, lifelong resident of the ward, wrote of the canal, "Drained about the first of November, it became the repository of tin cans and dead cats and was as unsavory a mess as one could imagine. We never thought to apologize for it—it was part of the Third Ward and therefore all right." (Courtesy of the Rochester Public Library, Local History Division.)

This mechanical contraption was the South Plymouth Avenue canal lift bridge, which must have been something to see in action, with all wheels turning. These bridges tended to jam, sometimes causing huge backups on both the canal and the main thoroughfares. The bridge at West Main Street, notorious for getting stuck, won the nickname "Old Calamity." (Courtesy of the Rochester Public Library, Local History Division.)

This February 6, 1903 view looks southward at the South Fitzhugh Street Bridge. Shown are the pedestrian bridge and the old Lockport and Medina Stone Yard. Virginia Jeffrey Smith mused that Dewitt Clinton's real reason for building the canal was "to act as a moat for the Third Ward. Each intersecting street had its drawbridge and we were serene in our isolation from the rest of the town." (Courtesy of the Rochester Public Library, Local History Division.)

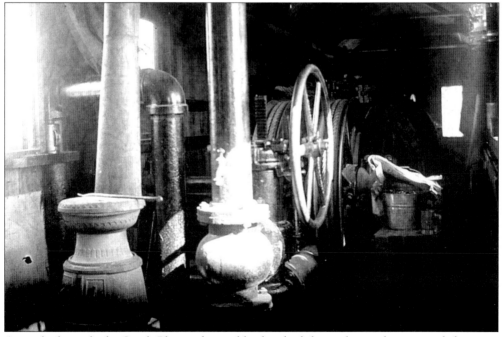

A rare look inside the South Plymouth canal bridge shed shows the machinery needed to raise and lower the bridge. The potbelly stove kept the bridge's captain warm. Each bridge had a captain or tender. (Courtesy of the City of Rochester.)

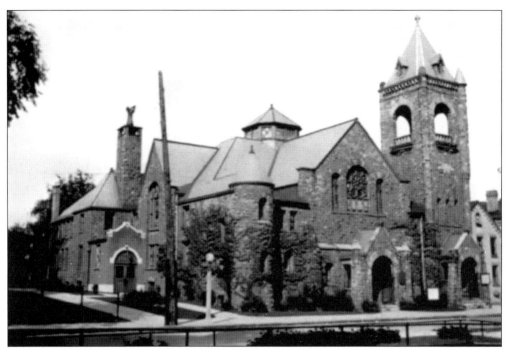

Among the beautiful churches around Plymouth Circle is the Corn Hill Methodist Church, on Edinburgh Street, shown c. 1900. Dedicated in 1900, it and replaced a previous 1854 structure. In 1968, its name was changed to the Corn Hill African Methodist Episcopal Zion Church. It was heavily damaged by fire in 1971 and razed the next year. A portion of the entrance was saved and incorporated in the new church. (Courtesy of the Rochester Public Library, Local History Division.)

Three gentlemen enjoy Plymouth Circle on a brisk day c. 1915. (Courtesy of the Rochester Municipal Archives.)

This view across Plymouth Circle shows a Second Empire–style rectory built in 1871. The building was later used as a convent for Immaculate Conception Church. A large Third Ward Irish congregation built the first church and convent here in the 1850s.

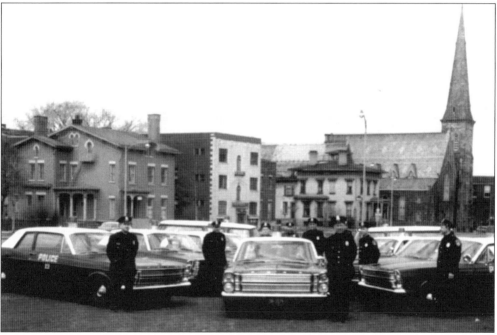

Policemen pose with their cruisers on a lawn where the civic center later rose. The homes and apartments across South Plymouth Avenue are gone now. The landmark First Presbyterian Church, built in 1872 and noted for its tall spire and Tiffany windows, remains a Third Ward landmark, on the corner of South Plymouth Avenue and Spring Street. In 1974, the congregation merged with two other congregations and became the Downtown United Presbyterian Church. Subsequently, this building became home to the Central Church of Christ. (Courtesy of the Rochester Public Library, Local History Division.)

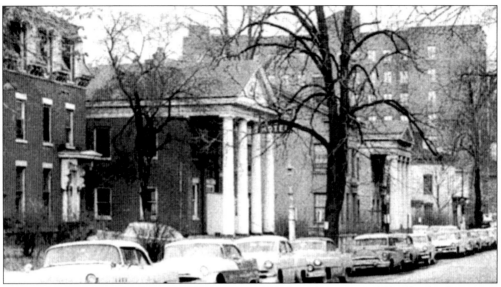

South Fitzhugh Street has a history unto itself. In its glory days, it was full of lively characters, varied businesses, and stunning homes. This photograph was taken just before all this came down for the civic center. Visible far down the street are St. Luke's Church and the Watts House, which, today, is tucked beside the civic center garage. Parking meters have replaced hitching posts, and cars have obviously stressed the once placid street. Even before civic projects threatened to obliterate the ward in the 1940s, people were beginning to realize that this was an architecturally significant area. Their coming battles to save what was left would be hard fought. (Courtesy of the Rochester Municipal Archives.)

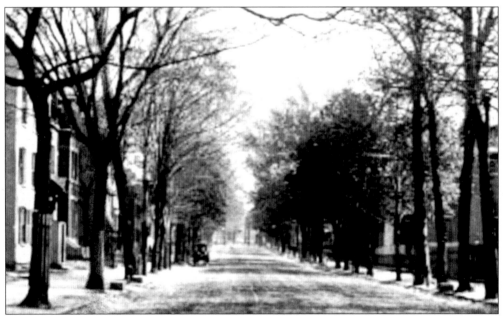

Shaded by trees and lined with impressive gates, South Fitzhugh Street was lovely in the 1870s. Barely visible on the left side of the street are the Jerome brothers' houses, at 88 and 90. Leonard Jerome's daughter Jennie was the mother of Winston Churchill.

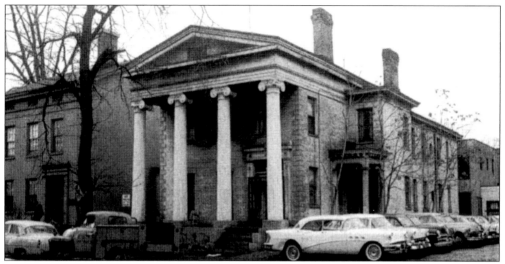

By the mid-1950s, the Meech House, at 71 South Fitzhugh Street, had become the Barclay Apartments. Although its bloom had faded, the c. 1830s structure remained exceptionally sturdy. The gradual decay of the ward continued. Forward-thinking city planners could not imagine how structures like this could have any part in a modern city. Massive federal funds were made available to cities through urban renewal programs. As far as some planners were concerned, the whole of the Third Ward could come down. (Courtesy of the Rochester Municipal Archives.)

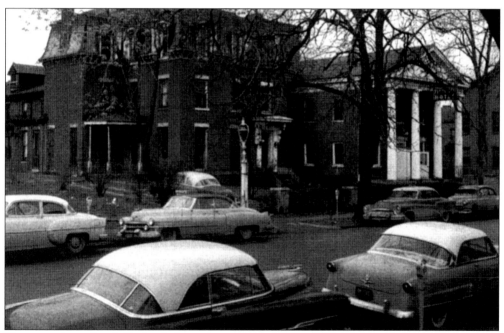

This view down South Fitzhugh Street brings back the glory days of the 1950s automobiles. The ward was not designed to accommodate these vehicles—one of the reasons that families began to abandon it. An earlier reason arose when Rochester became the Flower City. New neighborhood tracts were laid out with larger lots for those wanting more gardening space than was available in smaller Third Ward yards. (Courtesy of the Rochester Municipal Archives.)

South Fitzhugh Street's entrance to the ward was made in grand style via the magnificent Rochester Savings Bank building. This detail from a photograph taken in 1903 from the bell tower of the courthouse also shows men watching the fire that destroyed the Brick Presbyterian Church, on North Fitzhugh Street. (Courtesy of the Rochester Public Library.)

Smoke from industrial stacks along the river combines with the pall of smoke from the fire that engulfed the Brick Presbyterian Church in 1903. (Courtesy of the Rochester Public Library.)

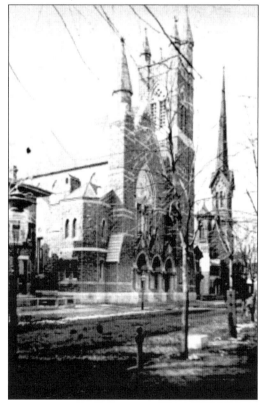

A late-1870s stereo view of the First Baptist Church that stood beside the Brick Presbyterian Church on North Fitzhugh Street shows many details from that time. Notice the simple oil lamp on the left, the brick sidewalks, the carriage stoops, and the hitching posts. (MLL Collection.)

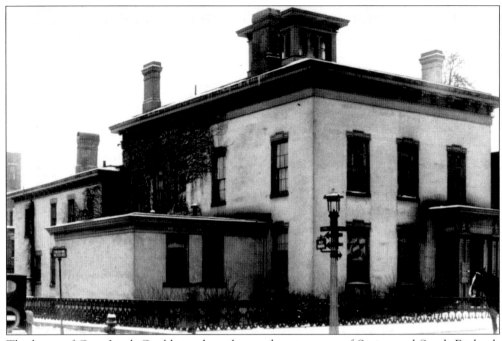

The home of Gen. Jacob Gould stood on the northwest corner of Spring and South Fitzhugh Streets. Pres. Martin Van Buren was guest at a reception held here in his honor. Gould was an early mayor, and he and his brother were shoemakers. (Courtesy of the Rochester Public Library, Local History Division.)

This early-1880s stereo view offers another look at the entrance to the ward from South Fitzhugh Street. From left to right are the the courthouse, St. Luke's Church, the beautiful Rochester Free Academy, and the Rochester Savings Bank, before its final stories and sculptural roof were added. The church and the academy are examples of the Gothic Revival style.

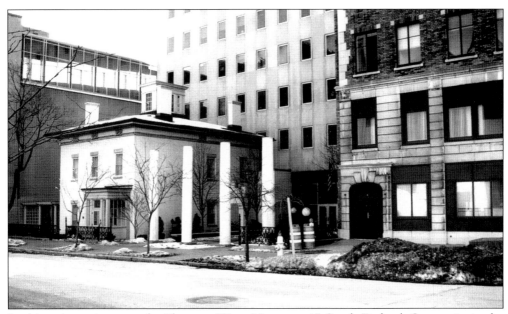

In this unique cityscape, the Ebenezer Watts House, at 47 South Fitzhugh Street, sits in the shadows of the civic center and its adjoining multilevel garage. Architects decided to build the complex around the house. Amazingly, the house withstood the massive construction project without being shaken down to its foundation. The columns of an old bank have recently been included in the park setting.

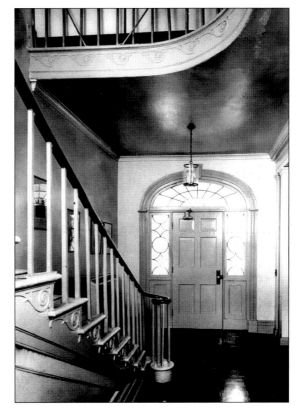

The foyer of the Watts House exhibits the exquisite craftsmanship of an early-19th-century home. Ebenezer Watts was a hardware dealer. This photograph was taken in 1968 by Hans Padelt for the Historic American Buildings Survey.

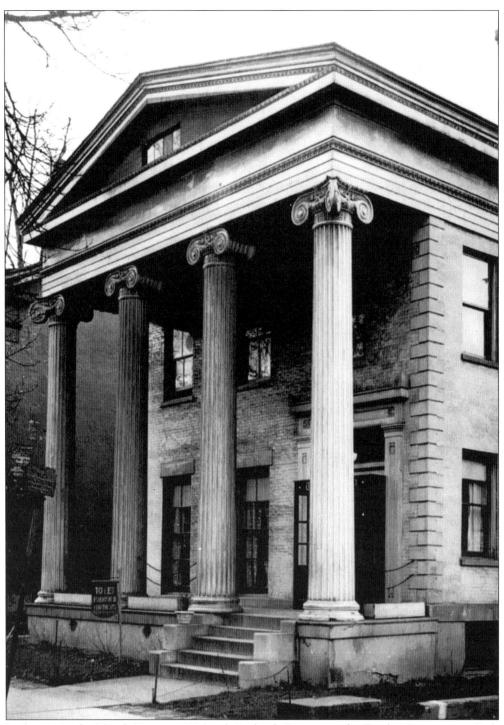

In the 1930s, the Meech House, at 71 South Fitzhugh Street, was the Barclay Apartments. Built nearly a century earlier, the house embodied the dignity and elegance of the Third Ward as few others did. Even as a neglected apartment building, it stands straight and rock solid—proud that it can still be of service. (Courtesy of the Landmark Society of Western New York.)

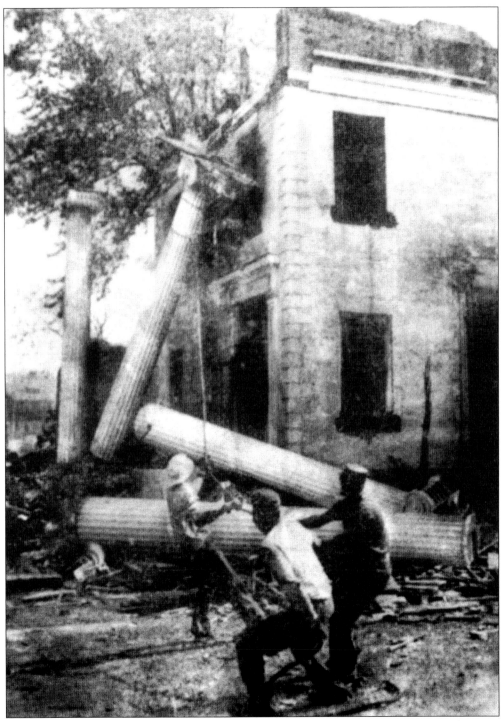

In an almost primal scene where a once grand beast is wrestled to the ground, the Meech House is pulled down in 1957. Scenes of urban renewal destruction like this galvanized the public against further demolition and made Rochester a national model for historic preservation. (Courtesy of the Rochester Public Library.)

Built in the 1830s on the corner of Exchange and Glasgow Streets, this house had an unobstructed and pastoral view of lawns and meadows sloping gracefully down to the the river. With the building of the railroad yards, that view became a thing of the past. In the 1860s, the owners, the French family, graciously opened their house to the public on New Year's Day. They would have eight or so young women over to receive the stream of 60 or more young men who would arrive in their sleighs to enjoy a light luncheon of oysters, coffee, and small cakes.

The brick Weddle House is lifted from its foundation on Exchange Street and moved to its new site on Adams Street. In 1969, Rochester became one of the first municipalities in New York to install a preservation ordinance in its zoning code. Frustrated by the demolition in the Third Ward, the Landmark Society of Western New York reexamined its mission and adopted an activist approach to preservation. (Courtesy of the Landmark Society of Western New York.)

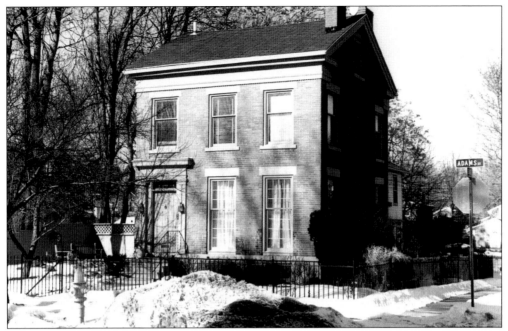

At its new location on Adams Street, the Weddle House looked as if it had always been there. With a few successes, the newly formed Landmark Society of Western New York set its sights high. Its first major project was an inventory of 700 buildings in the Third Ward slated for demolition under the urban renewal program. Using volunteers and limited funds, the society managed to get most of its proposal adopted by the city and urban renewal agency. As a result, those buildings were not demolished.

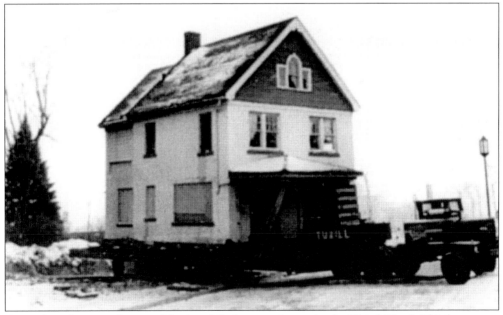

An orphan from another neighborhood finds a new home in the Third Ward. This house was formally at 38 Greig Street. In 1975, it was moved to Adams Street and completely renovated. (Courtesy of the Landmark Society of Western New York.)

The station for the Rochester and Eastern Rapid Railway and the Rochester and Sodus Bay Railway stood on the northeast corner of Court and Exchange Streets. From it, passengers could take large comfortable trolleys called interurbans to other cities and towns. As early as 1910—about the time this photograph was taken—a growing annoyance with electric railways developed in the city. The trolleys were involved in accidents; the roads were constantly being ripped up to repair the tracks; the overhead lines were unsightly. The Erie Canal was falling out of favor as well. It smelled, and the bridges over it always needed repair. Talk of rerouting the canal around the city increased, as did speculation about building a subway to get trolleys off the streets.

A stereo view of Plymouth Avenue looks south toward the Spiritualist church in the 1880s. It shows a tree-lined street of very closely packed homes. (MLL Collection.)

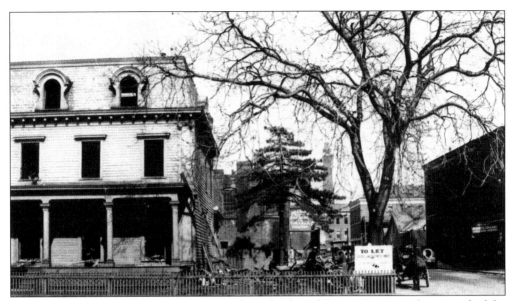

The Fitzhugh House, on the corner of South Fitzhugh and Spring Streets, is being readied for demolition in 1915. The windows and probably much of the finer interior features have already been removed. Men on the lawn are salvaging pieces and putting them in the wagon on the street. The Fay Block would be built here. A sign by the tree advertises for tenants to let space. (Courtesy of the Rochester Public Library, Local History Division.)

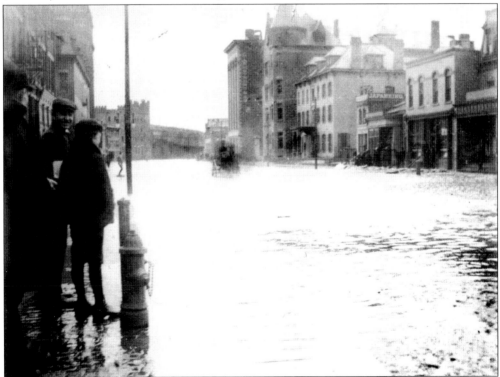

A March 1902 thaw has brought the Genesee River over its banks. Exchange Street, looking south, is under water.

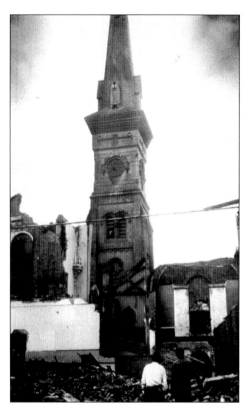

Demolition of the Spiritualist church, on South Plymouth Avenue, is under way in 1956. Built in 1854 as the Plymouth Congregational Church, the structure was considered the most beautiful house of worship in western New York for the rest of that century. The 200-foot spire shows up in many images of the ward. (Courtesy of the City of Rochester.)

The buttressed side of the Spiritualist church enjoys one of its last sunsets. The remarkable craftsmanship of the masons who built it is evident. Many Wardians set their clocks either by the large tower clock or by the tower bell clanging the hour. (Courtesy of the Rochester City Hall Photo Lab.)

The exquisite details of the Spiritualist church entrance are highlighted by subtle morning hues. (Courtesy of the Rochester City Hall Photo Lab.)

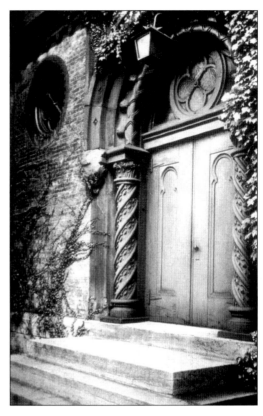

Before the wrecking ball arrives, workers on scaffolds prepare the Spiritualist church by weakening some of the interior supports. (Courtesy of the Rochester City Hall Photo Lab.)

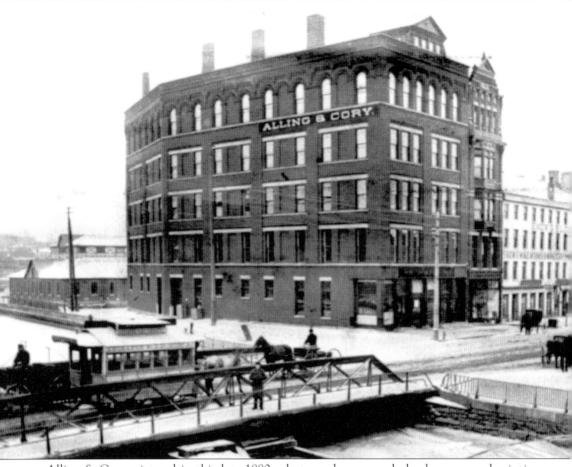

Alling & Cory, pictured in this late-1880s photograph, was a wholesale paper and printing materials firm. The War Memorial was built on this site in the 1950s. The Exchange Street swing bridge was the only one of its kind on the Erie Canal. The horse-drawn streetcar is headed south into the ward. Winter travel was hard on these early street railways. Hay was strewn on the car floors to help keep passengers warm. Later, small heaters were added. Drivers stood on the trolley platform outside in the cold to handle the horse. Wardians sometimes waited on their porches during snowstorms with hot soup and coffee for the drivers. Deep snow required switching to cars with sleigh runners. Drivers worked 10 to 12 hours each day. Duties from their rule book included the following: "Drivers must see that their horses are harnessed and safely hitched to their car and that their brakes are in good order; Each driver must have his change ready for morning before leaving for home at night. Conversing with passengers— this is forbidden except upon matters relating to the Driver's duties. Manage a balky horse by kindness. He should not be whipped but the car should be pushed steadily forward. Drivers must speak pleasantly to teamsters or anyone else in the way." (Courtesy of the Rochester Public Library, Local History Division.)

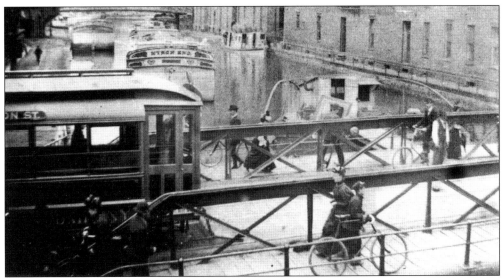

Looking northwest from the Exchange Street swing bridge, this *c.* 1900 view of the Erie Canal shows a busy commerce-filled day. This is the same bridge that appears on the opposite page; note that a new electric trolley has replaced the horse-drawn streetcar. In the early days of canal travel, arrivals and departures of passenger-laden boats at slips along the basins were usually attended with some fanfare, which might include the blowing of tin horns. It was "a daily spectacle which never lost its charm to youthful eyes," according to the reminiscence of a Third Warder. (Courtesy of the Rochester Public Library, Local History Division.)

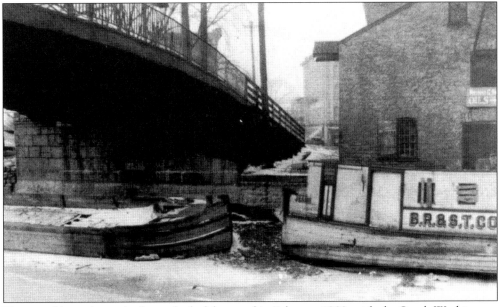

Two canal boats lie in the frozen bed of the canal in February 1903, with the South Washington Street Bridge on the left. Across the canal is the Norman C. Hayner Company, dealers in oils and boiler compounds. In early canal days, captains kept their boats clean and sometimes painted the sterns in vivid colors to attract customers away from other boats. Travelers often remarked favorably about the cleanliness of boats and the good meals served at the small dining tables. (Courtesy of the Rochester Public Library, Local History Division.)

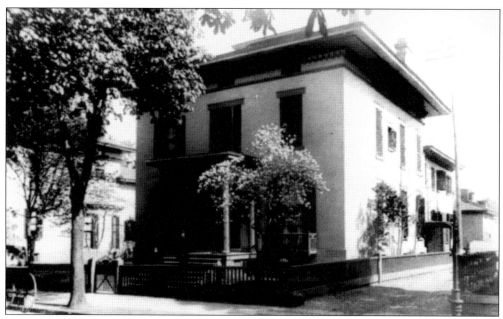

This series of photographs shows how well documented the Third Ward was, especially when preservationists tried to stem the threat of total destruction. Pictured here during the 1880s is the childhood home of author Samuel Hopkins Adams, at 135 Spring Street. The house was built in 1851 by James Crombie, a successful banker. (Courtesy of the Landmark Society of Western New York.)

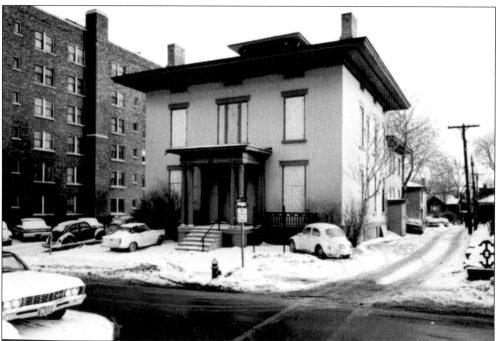

The same scene has changed in the 1960s. Although still straight, the house has been converted into a Rochester Institute of Technology dormitory. Can you count the Volkswagen Beetles? (Courtesy of the Landmark Society of Western New York.)

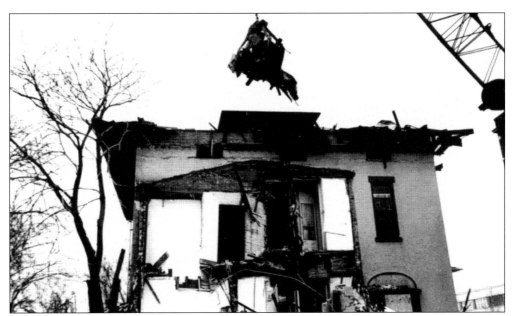

The Crombie-Mathew House is demolished in 1968 for an exit ramp off the Inner Loop. Samuel Hopkins Adams, who died in the 1950s but knew what was coming to his beloved home and ward, wrote, "Overriding the monuments of our past in order to achieve the shortest distance between two points may be correct engineering. When it sacrifices that which, 'once destroyed can never be supplied,' it is nothing less than vandalism. Let the juggernaut go around, not through and over, our historic landmarks." (Photograph by Bradley Hindson, courtesy of the Landmark Society of Western New York.)

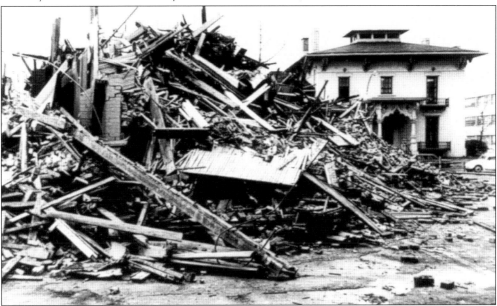

The Brewster-Burke House eyes the wreckage of its neighbor warily, as if wondering if its days are numbered. Fortunately that house remains with us today, having passed between owners who have been mindful of its architectural importance. (Photograph by Bradley Hindson, courtesy of the Landmark Society of Western New York.)

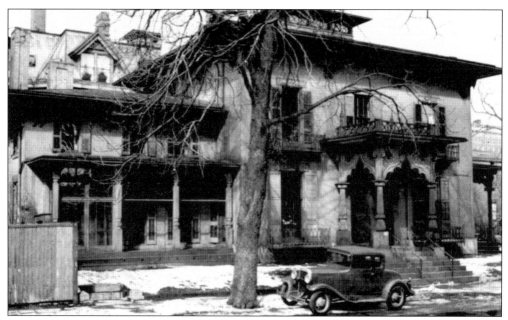

The Brewster-Burke House, on the northwest corner of Spring and South Washington Streets, was built in 1849 by Henry A. Brewster as a typical Italianate, a style popular in the 1850s. It was remodeled in 1856 into a Moorish fantasy that impressed neighbors of the time. When this photograph was taken in 1930 by Walter H. Cassebeer for the Historic American Buildings Survey, it was home to the Public Health Nursing Association.

This early example of decorative fencing around the Brewster-Burke House survived at least until 1930, when Walter H. Cassebeer took this photograph for the Historic American Buildings Survey. The house was built on lot 307 of the original 100-acre tract, laid out by the founders of Rochester in 1811. Brewster bought the lot in 1845 for $1,500; however, the land proved too small for a house, so he acquired an additional 12 feet to the north for a "consideration" of $500.

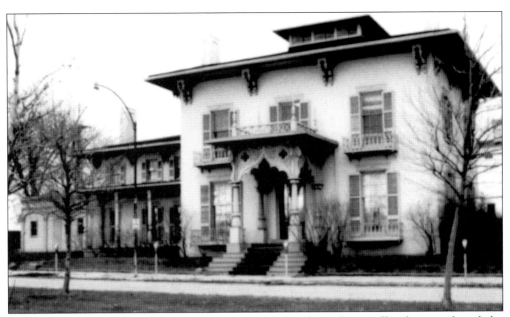

This contemporary view of the Brewster-Burke House shows how well it has weathered the storm. It was cut off from the rest of the ward when the highway went through.

A pedestrian bridge, running close to the original route of South Washington Street, spans the highway and connects the northern part of the ward with the rest of the residential district. Approximately 1,300 structures in the Third Ward came down for construction of the highway and civic center. The Landmark Society fought successfully to establish a conservation district in the northern part, where many historic buildings survived. The city designated it as the Third Ward Preservation District. The State and National Register of Historic Places lists it as the Third Ward Historic District.

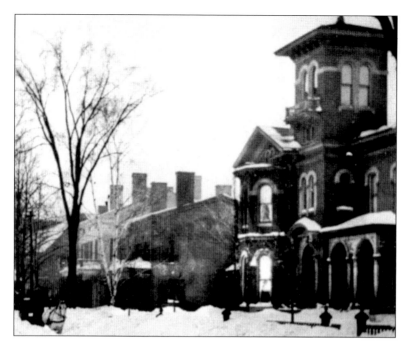

A lone sleigh braves South Plymouth Avenue after a major snowstorm c. 1900. The impressive home on the right was built in the 1860s for Emmett Hollister, a wealthy lumber merchant. The house has long since been converted to apartments. (Courtesy of the Rochester Public Library Local History Division.)

These two homes on South Plymouth Avenue were considered among Rochester's finest. Built a year apart during the Civil War, they equaled any of the other noted landmarks of the Third Ward. The Emmett Hollister House, on the left, was built as an updated Italianate. The one on the right was built in the Second Empire style by Charles E. Hart.

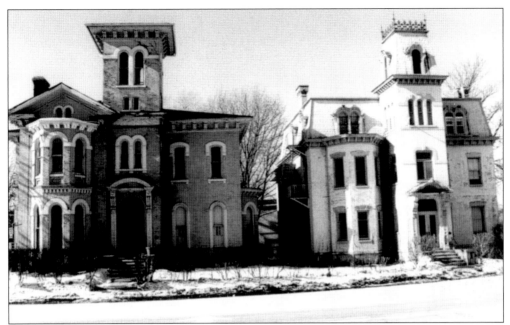

The Hollister House, on the left, and the Hart mansion, next to it, remain two of Rochester's most cherished landmarks. Quite prominent from the expressway, they still project the elegance of the Third Ward era when homes were built with an eye toward lavish entertaining. Longtime resident Virginia Jeffrey Smith wrote of homes such as these in 1952: "Their big, high ceilinged rooms were at their best when their crystal chandeliers reflected the gas jets on the evening dresses and white ties of the guests."

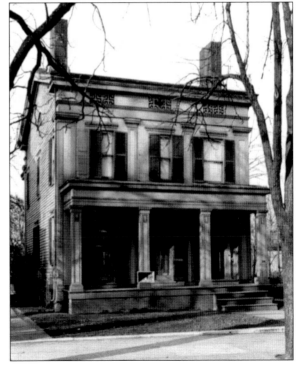

On the other side of the Hollister House stands this smaller but equally impressive Greek Revival, built in the 1820s for David Hoyt. The house was later owned by Charles F. Pond, who, in volume 1 of the Rochester Historical Society Publication Fund Series, gives a colorful tour of the Third Ward in 1895. This view of the Hoyt-Pond House dates from the 1930s. (Courtesy of the Landmark Society of Western New York.)

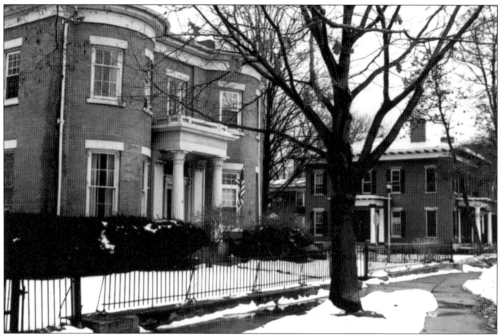

Along the strip of fine houses still standing on South Plymouth Avenue is the Amon Bronson House, on the left. The c. 1844 Greek Revival is one of the most distinctive in the Genesee Country, with two bow windows that represent the high level of architectural sophistication reached in the ward. On the right is the William Churchill House, built in 1848. Plymouth Avenue, like Fitzhugh, Exchange, and Washington Streets, started at Main Street in colorful and exciting commercial blocks that turned into elegant residential streets.

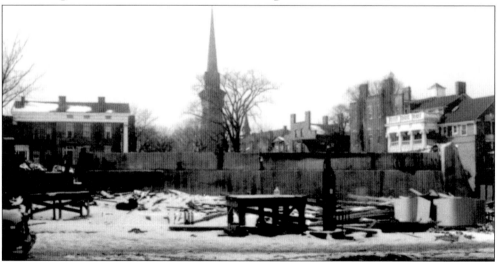

The swath of devastation continues, as can be seen in this new-versus-old photograph taken in the mid-1950s. Many citizens joined the flight to suburbia, believing that their old neighborhoods were destined to become ghettos. The federal urban renewal policies caused such widespread destruction in some of America's oldest neighborhoods that a national outcry finally led to the creation of the National Historic Preservation Act in 1969. Rochester became a national leader of preservation at that time. (Courtesy of the Rochester City Hall Photo Lab.)

The entrance to the Amon Bronson House is a typical example of the fine craftsmanship of the day. Many of these houses were built so well that they remain structurally solid to this day. Hans Padelt took this 1968 interior view for the Historic American Buildings Survey.

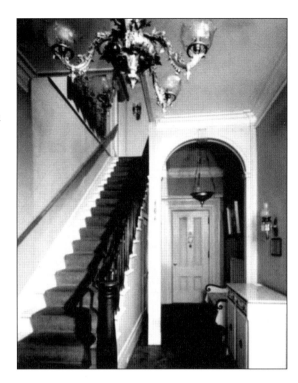

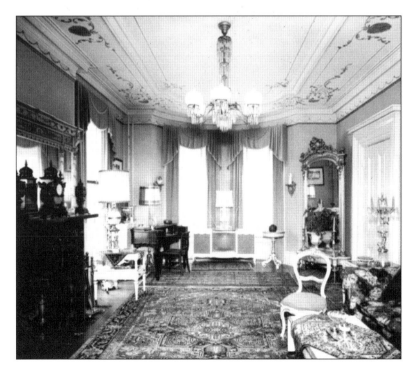

This 1968 view shows one of the parlors and bays of the Amon Bronson House. It was taken by Hans Padelt for the Historic American Buildings Survey. The room has a black marble fireplace, some intricate ceiling plasterwork, and at the end, an old French Provincial television, which looks appropriate in modern times.

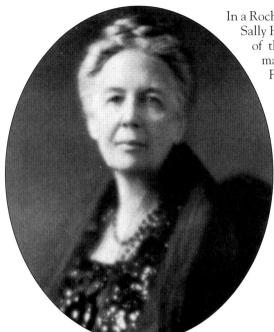

In a Rochester Historical Society volume from 1930, Sally Hall is remembered as a "true representative of the old Third Ward." She contributed to many civic and charitable organizations. From her porch on Spring Street, she chatted with the Montgomerys, Allings, Rochesters, and Livingstons—among others. Virginia Jeffrey Smith wrote, "The Third Ward is not just a geographical division, certainly not merely a political one. It is a village—a Cranford, a state of mind, an aura, a fetish—which only the Third Warder adores and which is an object of amusement, almost derision to the East Sider." (Courtesy of the Rochester Historical Society.)

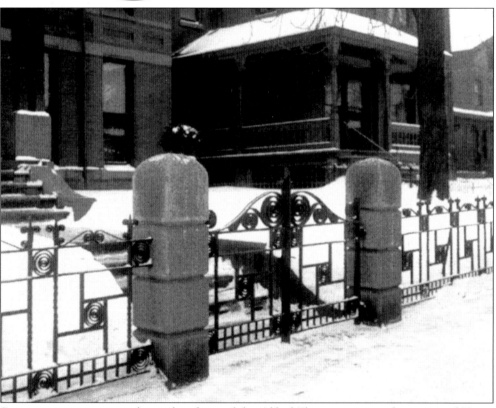

Some interesting gate work stood in front of the Alfred Ely mansion, on the corner of Troup Street and South Plymouth Avenue, in 1912. (Courtesy of the Rochester Municipal Archives.)

The Alfred Ely mansion was built in the 1880s on the corner of Troup Street and South Plymouth Avenue. Alfred Ely was a congressman during the Civil War. (Courtesy of the Rochester Public Library.)

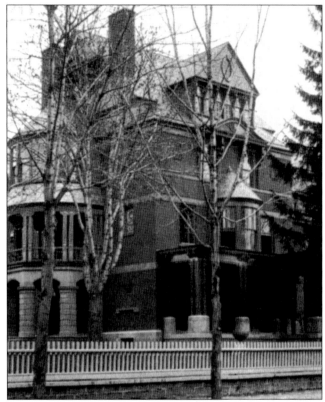

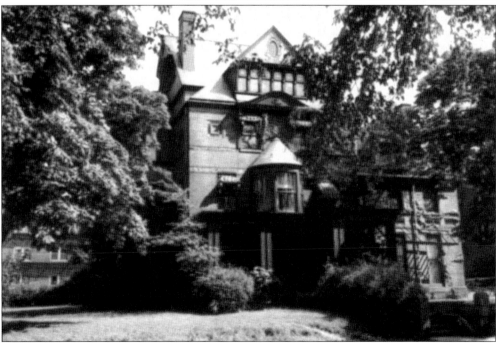

The Ely mansion was later abandoned as a residence and converted to the Mohawk Apartments before it was razed in 1958. (Courtesy of the Rochester Municipal Archives.)

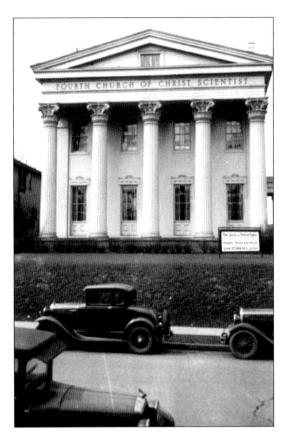

The Jonathan Child mansion was home to the Fourth Church of Christ, Scientist when this photograph taken in 1934 by Herbert Lawrence for the Historic American Buildings Survey. As Warders moved to the east side, they were pleased that their large houses were often used for "noble institutions." For all the harmless rivalry between east siders and west siders, the proud matrons of the ward pointed out that the east side owed its traditions and decorum to the Third Ward since it was from there that the original families came.

This is the South Washington Street Bridge as it appeared in the 1880s. The Erie Canal from Washington Street to the basin between Exchange Street and the aqueduct was the scene of unending activity. Young Third Warders often hung out on the bridges, watching the large packet boats pass under them. Occasionally, fights between crews broke out. To make their own excitement, boys would sometimes pelt passing boats with apples and tomatoes.

A *c.* 1900 view of the Washington Street Bridge includes the Jonathan Child mansion, on the right. This bridge and others were often the site of political rallies, demonstrations, and other events. Charles F. Pond recalls, "There was not an election in the Third Ward without a fight of some kind. If anybody came along and wanted to fight, he was accommodated." Few views exist of the Genesee Valley Canal on the southern border of the ward, but Pond mentions it: "Do you hear that horn? Well, that is the warning that the packet is approaching Mud lock on the Genesee Valley Canal." (Courtesy of the Rochester Public Library, Local History Division.)

Merchant-financier Chauncey Woodworth lived in this residence on South Washington Street beside the Brewster-Burke House. He developed Rochester's street railway system into one of America's most thorough. His dignified residence reflects Charles Milford Robinson's musings about the entrenched Warders in his Third Ward Catechism: "One became a Third Warder by birth, marriage or immemorial usage, . . . the chief and highest end of a Third Warder was to glorify the ward and enjoy it forever, for while there were, politically, other wards in Rochester, socially there were none."

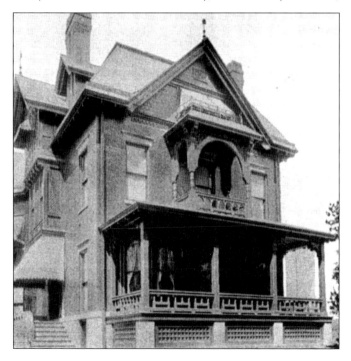

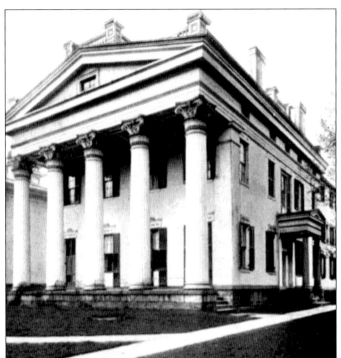

John N. Wilder, one of the founders of the University of Rochester, bought Jonathan Child's mansion in 1840. It was later a center of High Victorian entertaining. It hosted parlor games, costume parties, croquet, and lawn games. On summer evenings, blankets were spread on the lawn, as strains of Debussy, Verdi, Chopin, or Brahms spilled from the parlor windows. Mere steps to the north, the canal reflected the city lights and canallers dancing jigs to rigorous fiddle tunes.

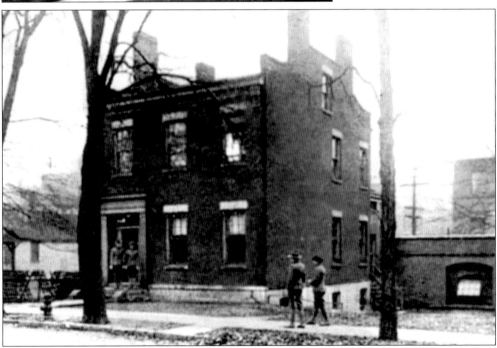

In 1918, during World War I, soldiers talk outside the Hostess House, on South Washington Street across from the Jonathan Child mansion. The house was established by the Mechanics Institute as a canteen where soldiers could go for recreation and entertainment. Built c. 1830, it was sometimes referred to as the Buell Homestead. The north side of the house actually touched the canal towpath. (Courtesy of the Rochester Public Library, Local History Division.)

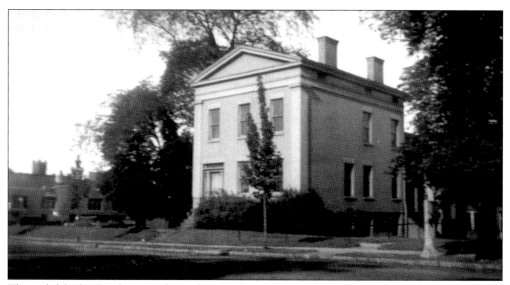

This solid little Greek Revival stood at 36 South Washington Street, just north of Rochester Institute of Technology's Bevier Building. It was built *c.* 1834 by Daniel Loomis for Nathaniel Thrift Rochester, son of the Col. Nathaniel and Sophia Rochester. Dr. Maltby Strong owned it while he was mayor of Rochester in 1854. Emma B. Swift took this photograph in 1940 just before the house was demolished. (Courtesy of the Rochester Public Library, Local History Division.)

The Jonathan Child mansion and a modern structure do not seem to be at odds with each other. The mansion has withstood the destruction that claimed so many of its neighbors. The sound of columns crashing to the ground and the pummeling of grand facades by wrecking balls has ceased, as a new generation of preservationists has come to appreciate this historic area. Today, the mansion enjoys the thoughtful stewardship of Edward's Restaurant.

A mere 38 visitors attended the first Corn Hill Arts Festival in 1968. An estimated 160,000 attended in 1980, when this photograph was taken. The number has grown steadily every year since. (Courtesy of the Rochester City Hall Photo Lab.)

This peaceful winter scene hardly conveys all the hardships the Third Ward has faced but shows the dignity with which it has survived. The nearby civic center is accepted because of the fine work devoted citizens have done there toward resolving conflicts between Rochesterians. Third Warders of old, in true pioneer spirit, might have gladly waved off their homes for such an addition to their realm. To those who think that not enough of the ward remains, a suggestion: walk its width and breadth, consider the hard work of those who saved it, and marvel at the realization that not only is there enough of it left, there is more than enough.